T0277134

# ILLUSTRATED TALES OF
# WARWICKSHIRE

S. C. Skillman

AMBERLEY

First published 2022

Amberley Publishing
The Hill, Stroud
Gloucestershire, GL5 4EP

www.amberley-books.com

Copyright © S. C. Skillman, 2022

The right of S. C. Skillman to be identified as the Author
of this work has been asserted in accordance with the
Copyrights, Designs and Patents Act 1988.

All rights reserved. No part of this book may be reprinted
or reproduced or utilised in any form or by any electronic,
mechanical or other means, now known or hereafter invented,
including photocopying and recording, or in any information
storage or retrieval system, without the permission in writing
from the Publishers.

British Library Cataloguing in Publication Data.
A catalogue record for this book is available from the British Library.

ISBN 978 1 3981 1093 9 (paperback)
ISBN 978 1 3981 1094 6 (ebook)

Typesetting by SJmagic DESIGN SERVICES, India.
Printed in Great Britain.

# Contents

# Introduction

Can such things be;
And overcome us like a summer's cloud,
Without our special wonder?

*Macbeth* (Act 3, Scene 4)

So says William Shakespeare, through the lips of Macbeth. This book is devoted to stories of the strange and curious, and since Warwickshire is Shakespeare's County, I cannot but be mindful that the bard himself was one of our greatest observers of curiosity in human nature. His hometown of Stratford-upon-Avon is justly famed for its beautifully preserved Shakespeare properties, upon which it thrives. But the one property we cannot see today, at New Place, is the very house Shakespeare lived in during the final years of his life, where he wrote some of his greatest plays. This is because a later owner, Francis Gastrell, had the house demolished in 1759 because he was so cross with Shakespeare tourists.

The play from which I quote above is often not named by the actors who are about to perform it: it may only be referred to as *The Bard's Play* or *The Scottish Play*. The reason for this may be found in a curse that no one believed in anyway during Shakespeare's lifetime.

Our lives are not essentially built on the logical and objective; they are built on our different concepts of the world, our observations and experience. There are plenty of stories to be found in this county that demonstrate what I may call 'the singularity' of human nature, and here I have collected a few examples, by travelling through the county, talking to people, and collecting the curious and strange like a magpie. Hopefully, Shakespeare would approve.

# I

# Strange and Spooky Tales

Oft have I seen a timely-parted ghost.

*Henry VI, Part II* (Act 3, Scene 2)

## The Hauntings in the Old Coffee Tavern, Warwick

As you walk from Warwick Market Square towards the Gothic tower of the Collegiate Church of St Mary, along Old Square, you will see on your left, at No. 16, the Old Coffee Tavern. You may well wonder, 'Why do they call it a tavern if I can only drink coffee there?' But a brief study of the menu will confirm that those who enter will find plenty on offer besides coffee, for it is now a pub, restaurant and hotel.

The tavern dates from 1880. It was built ten years after the state began to take more control of alcohol regulation and licensing, at a time when the Victorian temperance movement was campaigning against alcohol as a danger to society's wellbeing. Coffee was considered a much healthier alternative, and

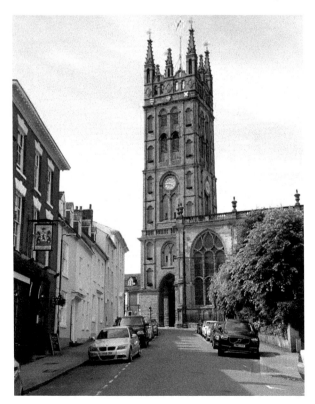

View looking up Old Square, Warwick, towards St Mary's Collegiate Church. (Courtesy of Abigail Robinson)

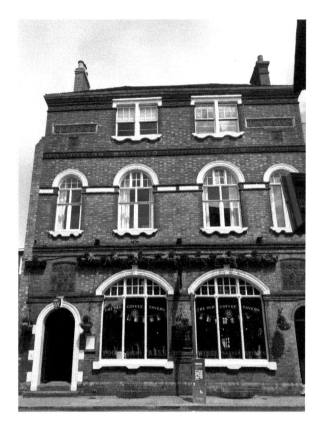

The Old Coffee Tavern,
Warwick. (Author)

local manufacturer and philanthropist Thomas Bellamy Dale may lay claim to the idea of this tavern. Public houses were held responsible for the poor health and drunkenness of the working class people of Warwick. Dale's coffee tavern and hotel was built to offer people a teetotal alternative to public houses and alcohol. Nowadays it is fully active again as a tavern in the currently understood sense of the word.

The building has also been used in the past to house offices of the Warwickshire County Council. Many spooky events have been reported by council staff working in the building over the course of decades. One of them, Philip Wilson, reports that throughout a long career in the council, frequent unsettling experiences convinced him and his colleagues that the property was haunted. Philip, now the Trustee, Secretary and Archivist for the Warwickshire Yeomanry Museum Charitable Trust, told me:

> I joined the Warwickshire County Council in September 1964 and worked in Shire Hall. In 1958, the Council had procured the building adjacent to 16 Old Square, formerly known as the Old Coffee Tavern. This building became known as 'the 1958 block'. In January 1965, I moved to the offices of the County Welfare Department on the ground floor of that block.

My earliest recollection of ghostly happenings there begins at that time. I remember an uncomfortable feeling as one entered the basement of the block from the passenger lift: it was as if somebody was watching you. The feeling got stronger as you unlocked the first storeroom door almost directly opposite the lift shaft. Whatever it was seemed to follow you round in the stationery storeroom: likewise, it was present in the second storeroom, next to the first. I was always glad to get back out and lock the door behind me. Others who worked in that storeroom on a daily basis were also convinced it was haunted. The same uncomfortable feelings occurred whenever I went into the basement storerooms at 16 Old Square.

Philip reports that the 'frisky spirit' haunting the basement rooms clearly had a special interest in females.

Curious experiences were reported by young female staff in particular: they felt the invisible touch of a hand in the basement rooms both of 16 Old Square and the 1958 Block. Because of this, they would only go into the storerooms in pairs. In 1972 I became the Social Service Department's first Budgetary Control Officer. I worked with other senior staff late into the night for several months each year on the Annual Budget. The bridge connecting the 1958 block to the Coffee Tavern was built in the early 1970s. We would vacate the block at 10 p.m. most nights by way of the bridge and walk down a large wooden staircase in the dark, closing the front door of 16 Old Square firmly behind us. On leaving the building late at night, despite being with others, one sensed a clammy, uncomfortable feeling as if being followed by a ghostly presence. There was no such presence during the daytime, the stairs being warm and inviting. Years later, I encountered that cold clammy presence again when Social Services Finance stored their files in the basement of the Coffee Tavern.

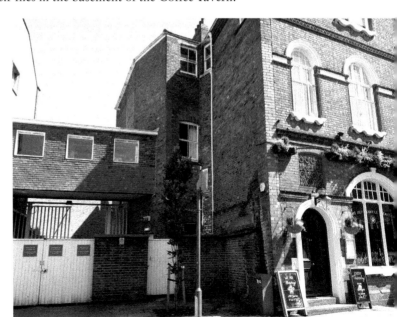

Bridge between Shire Hall and Old Coffee Tavern, Warwick. (Author)

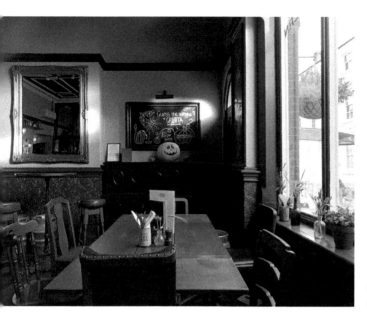

Old Coffee Tavern bar.
(Author)

Sadly, however (for ghost hunters), the presence in the basement has chosen not to migrate upstairs to the bar, because none of the staff I spoke to were prepared to admit to having experienced anything spooky, unless that be the sight of 'Gretta the Ghost Pumpkin' on the piano.

## Footsteps in Derelict Seventeenth-century Coaching Inn near Knowle

Richard White, National Trust Gardener, describes his unsettling experience as a schoolboy, back in 1967 at the current west border of Warwickshire, where the county adjoins the region now known as the West Midlands.

Richard and his friend, both aged fifteen, were exploring a derelict seventeenth-century coaching inn near the village of Knowle. They had brought their air rifles with them to shoot rats. In one of the empty rooms, they heard the sound of leather boots walking with slow and deliberate footsteps across the flagstone floor towards them. Both turned, saw nobody, exchanged glances, and fled from the building. Once outside, they screwed up their courage, and agreed to go back in. 'If those footsteps belonged to a ghost, we decided, we'd shoot that ghost full of pellets.'

Re-entering the property, they shot their air rifles into the dark: no one was there. Unnerved by the experience, they went home. However, they returned two days later, feeling sure it was an intruder, and they expected to find muddy footprints on the flagstone floor or around the property, but they saw nothing. In the following weeks and months, they both returned on occasions and went round it several times – with their air rifles levelled in case they saw someone.

Richard's current home is in Farnborough, Warwickshire. One day in 2009 he happened to find himself at the scene of his youth, and curiosity drew him back

Room in abandoned building.

to the property, since converted into a private residence. He knocked on the front door, which opened to reveal the current resident. Richard explained that he'd lived in the area as a young boy. 'Do you ever hear loud noises?'

The resident gave him a strange look and said, 'Why?'

'Footsteps. Leather boots.'

'How did you know about that?'

Richard described their experience in 1967. The resident replied that he too heard the same footsteps – across his kitchen. He invited Richard in and showed him through to the room in question. He and his wife had chosen to retain the original flagstones for their kitchen floor.

This and many similar stories uphold the theory that stone may act like a magnetic tape on a tape recorder. No seventeenth-century coaching inns remain derelict in 2021, having all been converted into residences or pubs, restaurants and hotels, where, doubtless, phantom footsteps still cross stone floors, and mysterious voices, phenomena and ghostly apparitions may sometimes still be sensed.

## Strange Experiences in St John's House Museum, Warwick

St John's House in Warwick is a seventeenth-century mansion, considered one of the most important buildings in Warwick, and long associated with paranormal events. Built by Anthony Stoughton in the year 1626, the house remained in the possession of the Stoughton family until 1960. The land on which the current house stands has a 900-year-old history, which begins during

St John's House, Warwick. (Courtesy of Jamie Robinson)

the reign of Henry II (1154–89), when William de Beaumont, then Earl of Warwick, decided to build a hospital here. This became known as the Hospital of St John the Baptist, which provided help to the local poor and ill, and also acted as a bed and breakfast establishment for impoverished travellers such as pilgrims. During the Dissolution of the Monasteries (1536–41), St John's was granted to Anthony Stoughton Sr, but not until his grandson Anthony Stoughton Jr inherited the property was a residence built on the site.

By the time Anthony built his house the hospital was no longer active, but back in 1610 the site had comprised four buildings, including a chapel and a gatehouse with crenulations. The site also included a cemetery; remains have often been dug up during refurbishment work. This does appear to offer one reason for some of the curious experiences reported by visitors in more recent times.

Over 160 years later, the building was converted into a school, which continued until its closure in 1900. After the Stoughton family sold it to the War Department, St John's House was bought by the Warwickshire County Council along with the Royal Regiment of Fusiliers (Royal Warwickshire), who own it to this day. It is now a museum, with several rooms dedicated for the use of local school children, including a Victorian kitchen and schoolroom, and galleries with displays on childhood, toys and games, and costumes. The first floor is devoted to the Royal Warwickshire Regiment of Fusiliers Museum.

Many visitors believe the property to be haunted. A woman dressed in period clothing has been seen on several occasions standing in front of one of the windows looking out. Local resident Graham Lockley recalls that during a family visit to the St John's House Museum, one of his children had a 'strange experience' in one of the upstairs rooms, which would in former times have been a bedroom. Ghostly children's laughter, footsteps and cries are often heard in this area – evidently not from the living children who are investigating the rooms! Several reports have emerged, too, of an angry presence in the cellar, where poltergeist activity is very common. Visitors often refuse to go back in there due

to a feeling of being pushed and grabbed, and the sound of doors banging is often heard.

The building is the venue for occasional ghost tours: Haunted Happenings organises overnight Ghost Hunts in the property. They say: 'Ghost Hunts at St John's Museum are extremely daunting and leave you in no doubt of paranormal activity.'

## Hall's Croft: Dr John Hall's House, Old Town, Stratford-upon-Avon

Hall's Croft, a beautiful timber-framed building in Old Town, Stratford-upon-Avon, is the former residence of Susanna, Shakespeare's daughter, and her husband, renowned local physician Dr John Hall. John and Susanna lived here with their young daughter Elizabeth from 1613 to 1616. Many stories of hauntings are forthcoming from both staff and visitors.

As in the case of St John's House, Warwick, this building formerly functioned as a school for many decades, and this seems to be the cause of some of the curious experiences reported in the property. These include the sound of children crying and wailing, which can regularly be heard coming from the first-floor room at the far right-hand side of the property (as viewed from the road outside). The apparition of an English Civil War soldier has also been sighted in the ground floor room on the left of the property.

In 1949 the Shakespeare Birthplace Trust acquired the building. Prior to that, Hall's Croft had seen many different residents, including actors and

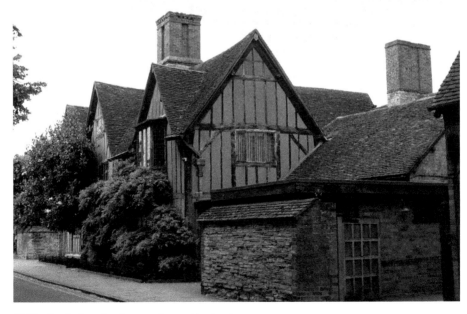

Hall's Croft, Stratford-upon-Avon. (Author)

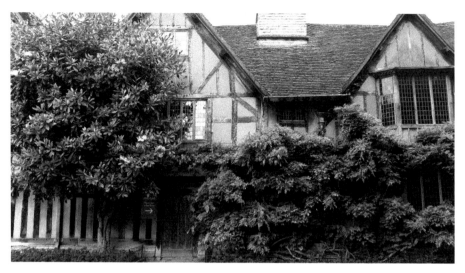

Hall's Croft, Stratford-upon-Avon. (Courtesy of Jamie Robinson)

employees with the Royal Shakespeare Theatre. Throughout the summer months Shakespeare plays are performed in the garden. On one such occasion, during the interval, an audience member reported having seen the apparition of a First World War nurse, standing by the rear wall of the garden. Historical research confirms that the building across the road from Hall's Croft, now a private residence, was used as a temporary hospital during the First World War. It is therefore quite likely some of the nurses may have spent time in the tranquil garden of Hall's Croft, seeking respite from their challenging daily work with injured soldiers.

Other curious tales are recounted of Hall's Croft, in which staff and visitors claim to have seen the apparition of Betty Leggett, who was resident at Hall's Croft during the Second World War. Betty tripped and fell down the stairs in 1944, and ultimately died of her injuries. Her presence, though, continues to make itself known from time to time; once by a young waitress in the café, who, while closing up one evening, saw a vision of Betty's face with flaming red hair, through the glass of the internal door. Betty's influence is also sometimes felt by visitors on the stairs down which she fell. Several report an unsettling experience here: having left the exhibition on the first floor, while descending to the ground floor they sense a change in temperature, and believe they are being pushed from behind, with no apparent physical cause.

The medical exhibition showcases several curious instruments, items and techniques Dr John Hall would have used in the 1600s during his medical career. Modern science has confirmed the medical value of some of his methods, including his use of the saliva of a frog to ease a sore throat. Analysis of samples of that saliva has revealed the existence of antiseptic and anaesthetic qualities. Thus, today in our language we may find the saying, 'I've got a frog in my throat.' A visit to the first-floor exhibition at Hall's Croft will prove highly instructive for anyone fascinated by the history of medicine.

# 2

# Extraordinary True-life Stories

Do not so,
To make my end too sudden.

*Richard II* (Act 5, Scene 1)

## Robert Greville, 2nd Baron Brooke, Owner of Warwick Castle: First Man on English Soil to be Picked Off by a Sniper

Robert Greville, 2nd Lord Brooke (1607–43), inherited Warwick Castle in 1628 from his predecessor Sir Fulke Greville. Visitors taking a tour at Warwick Castle will be made well aware of Sir Fulke's horrendous death at the hands of incompetent medics. After being stabbed by his manservant, Sir Fulke's agony was compounded by his medical treatment, and septicaemia ensured his demise. He bequeathed Warwick Castle to his distant cousin and adopted heir Robert.

As a dedicated Puritan, Robert had proved himself an outspoken and passionate opponent of Charles I well before the outbreak of the English Civil War. When war came, he was appointed Parliamentary commander for Staffordshire and

Warwick Castle courtyard from Guy's Tower. (Courtesy of Abigail Robinson)

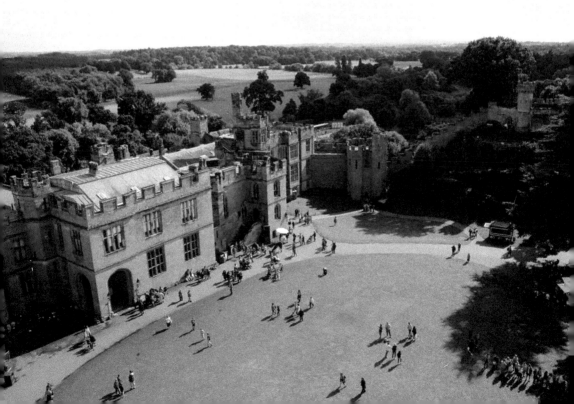

Warwickshire, whereupon he swept away Sir Fulke's exquisite formal gardens to make way for gun placements.

On 23 August 1642, Robert Greville's troops repulsed an attempt by the Earl of Northampton to capture Warwick Castle. He raised a regiment, which fought at Edgehill in October, and he helped to drive back the Royalist advance on London at Brentford in November After he secured Stratford-upon-Avon for the Parliamentary side in February 1643, he moved on to Lichfield, where Royalist forces had taken shelter in the cathedral. Vowing to kill everyone in the cathedral, he was about to initiate a charge when he was shot dead by a Royalist sniper stationed on the central tower of the cathedral. The Royalists inside the cathedral may have rejoiced; but not for long, as a series of fierce engagements followed. These resulted in stalemate, the deaths of many, and the near destruction of the cathedral, which was not finally restored until 1860.

Meanwhile, Robert gained the distinction of having been the first man on English soil to be shot by a sniper. He was buried in the Collegiate Church of St Mary, Warwick, in the Greville family tomb beneath the Chapter House, and Warwick Castle passed into the hands of his eldest son Francis, who held the castle from 1643 to 1658.

St Mary's Collegiate Church, Warwick, viewed from Guy's Tower, Warwick Castle. (Courtesy of Abigail Robinson)

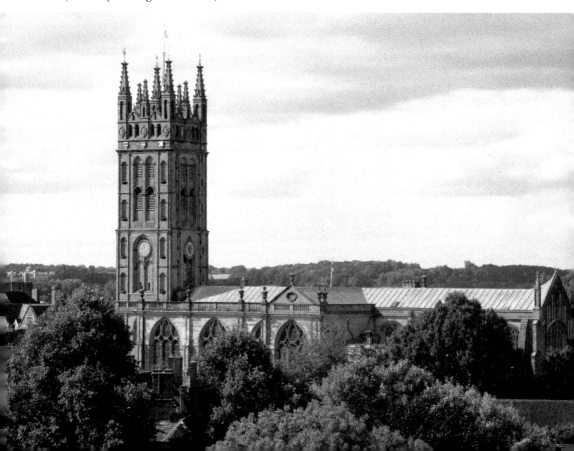

# Tales of Warwickshire Witchcraft

This only is the witchcraft I have used.

*Othello* (Act 1, Scene 3)

### Ann Tennant in Long Compton: A Witchcraft Murder

It is thought by researchers into witchcraft cases recorded at the Midlands Circuit Assizes that witchcraft did not in fact exist. What did exist was the terror and prejudice the mere idea of it aroused. This fear affected the minds of the population, spreading like an epidemic of superstition from the fifteenth to the seventeenth centuries in England, where witches were hanged (unlike in Scotland, where they were burned at the stake). Persecution of women for witchcraft was at its most intense during the English Civil War and the Puritan era of the seventeenth century.

Most of the victims were poor, elderly women. In total 2,000 were tried for witchcraft in England, and 25 per cent of those were condemned and executed.

Long Compton. (Courtesy of Jamie Robinson)

Continuing belief in witchcraft has given rise to some curious cases in village communities, showing that this belief lingered for at least 200 years longer than the date official persecution stopped. Paula McBride, researcher formerly of Warwick University, concentrated on the Midland Assize Circuit area of the Midlands for her MA by Research in History, and she told me she found very few cases in the county of Warwickshire, though a surprising number of cases for magic and witchcraft elsewhere in the Midlands. Nevertheless, two distinctive cases took place in Warwickshire as late as the nineteenth century.

An 1875 murder in the village of Long Compton is associated with fears of witchcraft. An elderly lady called Ann Tennant was stabbed to death with a pitchfork by James Haywood, a farm labourer. James believed many bizarre things about witchcraft in the area and considered Ann to have been a witch. A report later appeared in *The Times*, which described Ann as 'an old woman, of harmless character, whose ill fame as a witch depended on her sex and age and absolutely nothing else'.

James was found to be mentally unstable, but notwithstanding this, several members of the local community shared his opinions. Writing as late as 1928, Richard Clarke, the son of an eyewitness to the crime, wrote about the case in terms which suggested he considered the assumptions of witchcraft justified. It seems, therefore, that belief in witchcraft persisted well into the twentieth century, certainly within rural communities.

## The Mysteries Surrounding Meon Hill

Just outside the village of Lower Quinton, Meon Hill appears to be a peaceful pastoral scene. The site of an Iron Age hill fort, it has, in the popular local imagination, long featured as a setting for mysterious and sinister events. Strange tales have surrounded the hill for many centuries, concerning devilish deeds and ancient hauntings.

One legend from the eighth century says the Devil kicked a boulder from the top of the hill, intending to smash the recently built Evesham Abbey. The legend tells that his angry deed was thwarted by the locals' prayers and the stone instead fell on Cleeve Hill, outside Cheltenham. People there then carved the stone into the shape of a cross, to rid it of evil from the Devil's touch. Another version of the tale says the Devil threw a large clod of earth to smother the newly built abbey. However, the Bishop of Worcester saw the Devil and with the power of prayer altered the Devil's aim. In this version, the clod fell short of its target and formed Meon Hill.

In English rural communities such as those near Meon Hill, it may be that such stories were devised by the religious authorities, as an instrument of psychological and emotional power. However, some legends predate the church, including the tale of phantom hounds belonging to the Celtic king Arawyn, hounds which are said to hunt through the hill at night. This particular king was the lord of departed spirits who would hunt to gather souls, riding a pale horse and accompanied by

Meon Hill with sign in front. (Courtesy of Jamie Robinson)

a pack of white hounds with red ears. Some of those who cross the hill have long reported mysterious black dogs in the area. This does tend to bode ill for those dogwalkers who are giving their faithful black Labrador daily exercise, but perhaps such innocent walkers avoid the hill for this very reason!

Meon Hill is also the site of the longest unresolved murder in the records of Warwickshire Police (see chapter on Rural Crimes).

## Accusations of Witchcraft in Sheep Street, Stratford-upon-Avon, in 1867

In the Midland Circuit Assizes we may find the 1867 case of John Davis of Sheep Street, who attacked his neighbour Jane Ward, claiming that she was a witch who had laid a curse on him and his family. On 3 December of that year, he appeared at the Warwickshire Assizes for 'wounding with intent to do grievous bodily harm'. But what provoked his violent outburst against Jane? Apparently, along with members of his family, he had branded her as a witch. Various newspaper articles found in the British Library Newspaper Archives give detailed accounts of his claims. He claimed she 'sent two headless ghosts in the dead of night down his chimney', one of which was 'the Patron Saint of Paris, Saint Genevieve'. The saint was said to be 'carrying his head under his arm like a gentleman would carry a cane'.

John Davis further claimed that the ghosts pinched family members, rearranged their furniture, and also pushed John's disabled daughter off the sofa and threw her around the room together with the sofa. These events led John to conclude

Sheep Street, Stratford-upon-Avon. (Courtesy of Jamie Robinson)

that Jane had put a curse on his family. He decided that in order to break the curse, he needed to draw her blood. Once he had done this, her witchcraft would be neutralised.

On the night of the attack, two women, identified as Davis's sisters, began to verbally abuse Jane near her front door. While this was happening Davis ran out and struck her twice in the face, first with his hand, and then again with a penknife, causing a wound just under her eye that was half an inch wide, and about two and a half inches deep. After the attack, the report went on, 'she tried to stem the bleeding with her apron, whilst shouting "murder"'. At this point Davis's sisters ran away. The night after the attack, John claimed to have slept soundly for the first time in months. He attributed this to the fact that he had broken Jane's spell.

Fortunately, the enlightenment of the times won out, and John was sentenced to eighteen months hard labour. Jane survived and, we may hope, recovered from her wounds and lived out her life with no further accusations of witchcraft from the neighbours.

# 4
# Rural Crimes

Thou ... hast within thee undivulged crimes.

*King Lear* (Act 3, Scene 2)

## The Lower Quinton Murder: The Longest Unsolved Murder Case in the Records of Warwickshire Police

With modern knowledge and techniques, it is highly unusual for a murder case to go unsolved in Warwickshire. However, police records contain one case which evaded all attempts at a solution by the finest detective then available: Robert Fabian of Scotland Yard.

The saga begins in the 1920s, when folklorist and historian J. Harvey Bloom collected the tale of a boy called Charles Walton, who was supposed to have had several encounters with a black dog in Lower Quinton. Phantom black

Lower Quinton farmyard scene. (Author)

dog sightings have long been associated, in the minds of the superstitious, with prophecies of death. These encounters preceded news that Charles's sister had died. This story was later picked up and associated with a brutal murder that took place close by on Meon Hill, decades later, in 1945. Yet this seems to have been a false association. The two individuals shared a name but could not have been one and the same person, as details of the earlier incident did not correspond with the known life history of the later murder victim. Despite this, the supposed relationship between the two events was at one stage offered as an explanation for the later crime: a local belief in witchcraft.

The 1945 murder took place at Firs Farm, Meon Hill. There, the hapless victim, farm labourer Charles Walton, who had gone up on the hill to trim the hedges, was savagely murdered with a pitchfork. Charles had been an inoffensive man in the local community, well known for his connection with animals. He held a reputation for his ability:

> to calm mad dogs, spooked horses and wild animals alike with a whistle. When his cottage was searched after his death the garden was found to be teeming with natterjack toads and locals claimed one bloated specimen was his favourite. It is certainly safe to say that Walton, while not a 'warlock' as some claimed, was very well versed in the old ways and lore of the countryside and its nature. As such he was seen as a strange throwback to a different time, harmless but distrusted by some. In earlier centuries he might have been known as a 'cunning man'.

The investigating detective, Robert Fabian of Scotland Yard, never managed to bring any charges for the crime. Despite exhaustive enquiries in the local community, he failed to make an arrest. The murderer walked free.

However, the story does not end there; rather, it has had an intriguing afterlife throughout all the decades since. Robert Fabian later wrote a renowned memoir called *Fabian of the Yard*. Within this memoir, he described the case and mentioned witchcraft; yet no reference to witchcraft may be found in his records of the case lodged at the time of the investigation. It seems he and his assistant were both infected by the suspicions of witchcraft, and ultimately associated it with the case, even though they originally came to the investigation with the best intentions of objectivity.

The cases Robert Fabian described in his memoir formed the basis for a British police procedural television series. The BBC broadcast the thirty-six-episode series between November 1954 and February 1956. Robert Fabian was the inspiration for the investigating detective, and one of the series writers. The murder at Lower Quinton remained the one case he never brought to a successful conclusion.

But Fabian did have a suspect; a man whom he personally believed to be the killer, on the basis of circumstantial evidence, but who could not be arrested and charged, as there was insufficient hard evidence to pin the crime to him. This

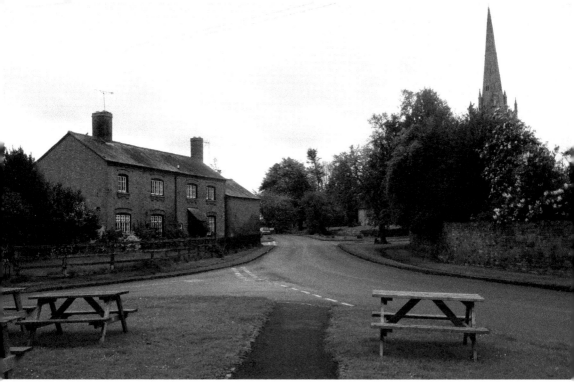

Lower Quinton. (Courtesy of Jamie Robinson)

man was Alfred Potter, Charles Walton's employer. Many of those who read and reviewed the book *Fabian of the Yard* were also convinced by this conclusion.

Today in Lower Quinton we may find a Warwickshire village full of desirable period properties, with a popular local gastro pub, The College Arms. To the eyes of the casual visitor, no long shadow lingers from the injustice that was dealt out to an apparently harmless, animal-loving farm labourer back in 1945.

As a postscript to this story, I received this comment from a source who has experience of working with Warwickshire Police:

Advances in forensics – both in the opportunities it presents, and how to capture and handle it – along with increased efficacy and awareness of time critical actions, advancement in investigative interviewing techniques and digital capabilities, all mean murders rarely go unsolved in Warwickshire today.

### The Plough at Eathorpe: The Centre of a Highly Successful Wartime Black Market Operation

A delightful pub in an idyllic village, The Plough today exudes charm and hospitality, just as it would have done in the 1940s; except then, it was a hive of illegal activity, and renowned as a supply centre at the heart of the black market.

A wartime resident of Eathorpe, Julie, explains that:

during the Second World War ... the black market operated and the racketeers who ran it were known as spivs. Eathorpe was a thriving centre for the local

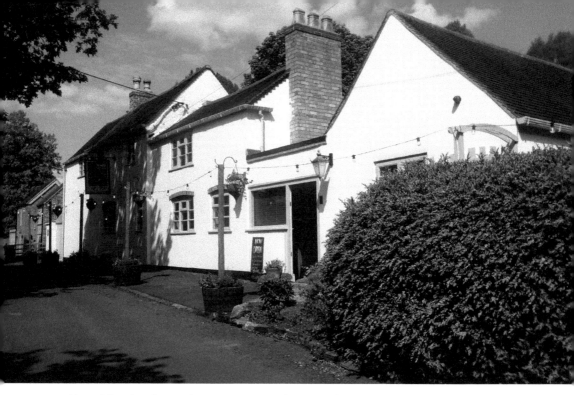

*Above*: The Plough at Eathorpe. (Courtesy of Jamie Robinson)

*Below*: Eathorpe. (Author)

black market and the Plough Inn was its focal point. Most people seemed to be involved. Anything you couldn't get in the shops you could obtain at the Plough Inn. People came from Coventry to buy the illicit goods. My mother used to sell our Bread Units to a Coventry businessman and his wife, because we didn't need them. Seekers of black-market goods would come to the Plough in the evening, buy a drink and sit in the smoking room with their pockets stuffed with carrier bags waiting for the landlady to appear at the hatch. She would quietly call a name and nod towards a room at the back of the inn. One by one, people would get up and disappear into the back of the pub where she would meet them and take them into her storeroom, where they could select the items they wanted: meat, fish, vegetables, oranges, bananas, sweets, clothes, and petrol coupons. Thick woollen blankets were sometimes available. We kept ours for about a fortnight, then the police came and took them from us. Unknown to us, they had been stolen from Weston-under-Wetherley 'Colony', as it was known then, before it was re-named Weston Hospital. Although sweets and chocolate were rationed, we never went short as my parents had contacts who kept us adequately supplied.

Weston-under-Wetherley. (Author)

# 5

# Intriguing People, Past and Present

Put thyself into the trick of singularity.

*Twelfth Night* (Act 2, Scene 5)

## Harry Ellard: Nightclub Owner Who Bought Compton Verney to Keep His Pigs and Entertain Guests in a Caravan for Twenty-five Years

The gracious Georgian mansion of Compton Verney and its elegant Capability Brown parklands have been through many changes of fortune, in common with several other English stately homes. A house was first built on this land by Richard Verney in 1442, and for centuries the mansion was the family seat of the Barons Willoughby de Broke. Only when agricultural rents dropped dramatically in the late nineteenth century did the family's fortunes begin to decline, and eventually

Compton Verney. (Courtesy of Jamie Robinson)

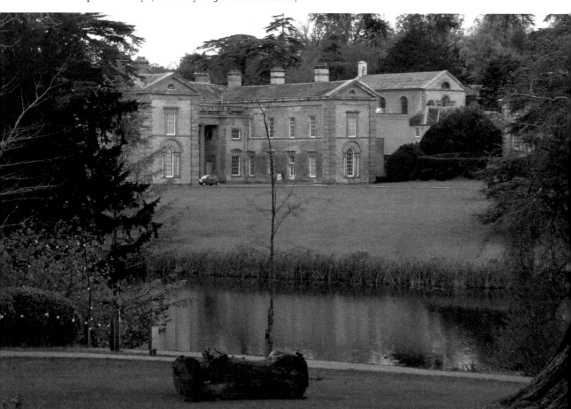

in 1921 the Verneys had to sell the property, while the latest baron withdrew to nearby Kineton to live in reduced circumstances.

The house and estate changed hands a few times and for a period of time was owned by Samuel Lamb and his German wife Gita. During the 1930s Samuel and Gita, in common with many landowners and aristocrats in England, entertained high-ranking Nazis, falling in with the efforts of Hitler's Germany to curry the favour of the great and good in England.

Gita became notorious for setting her dogs on the gardeners and failing to call them off till the last moment; an unsettling resonance with some of the cruellest acts of guards at Auschwitz. During the war the house and estate was requisitioned by the army and used as a barracks. When the war ended, the Lambs chose not to return, and Compton Verney declined. After Gita died, Samuel sold it to Harry Ellard, Solihull nightclub owner. Harry owned the house and estate for twenty-five years during which he visited weekly on Thursdays in an elderly Austin with scraps from his club to feed the pigs he kept there. He entertained guests in his custom-made caravan, parked in the grounds, and he rarely entered the house.

The 21st Lord Willoughby de Broke reported that his own occasional visits there were deeply depressing. He cited:

> rusting barbed wire fences, hungry Alsatians barking in the James Gibbs stables, and evidence of neglect everywhere: crumbling masonry, gaping holes in roofs, even a sapling growing from one of the former windows.

The James Gibbs Stables at Compton Verney. (Courtesy of Jamie Robinson)

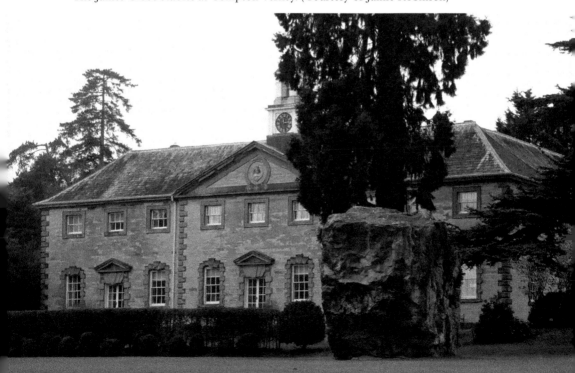

The best thing Harry did with the estate was to hire it out to film companies for their location shooting, and thus in 1968 Director Peter Hall filmed *A Midsummer Night's Dream* in the estate woodlands. The film starred Judi Dench, Diana Rigg, Helen Mirren, Ian Holm, David Warner and Ian Richardson. The Compton Verney woodlands stood in for 'a wood outside Athens'.

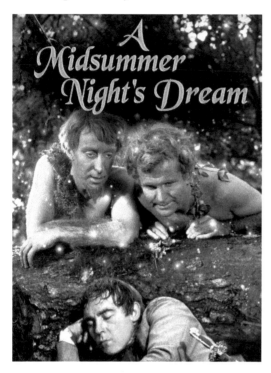

*Left*: Poster for 1968 Peter Hall film of *A Midsummer Night's Dream* filmed at Compton Verney.

*Below*: Compton Verney woodlands. (Courtesy of Abigail Robinson)

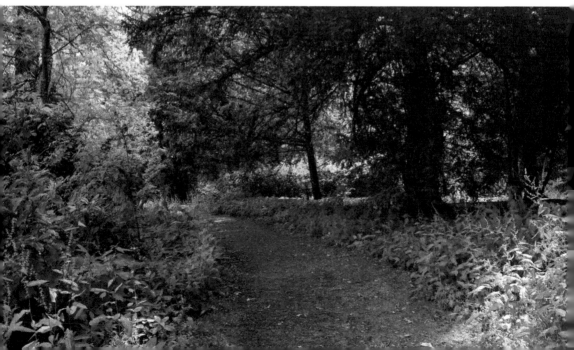

The Adam Hall at Compton Verney. (Courtesy of Jamie Robinson)

The film-makers used the Adam Hall inside the house for the final scene, and together with a large number of other local people I watched the film in that very hall on the fiftieth anniversary of the film's release.

By the time of Harry's death in 1983 the house's ceilings had buckled and collapsed, the walls had rotted, and the sky could be glimpsed from the ground floor. Compton Verney was fast becoming a picturesque ruin. Both house and chapel were listed Grade 1 by English Heritage yet still the future for both park and mansion looked bleak. The next owner made changes and improvements, but failed in his plans to build an opera house there. He finally sold it to the Peter Moores Foundation, who saved it by turning it into the beautiful art gallery it is today, set in glorious parkland.

## Daisy, Countess of Warwick, Who Started the Welfare State and Funded It Out of Her Own Purse

A major moral question today is how may we achieve the fair redistribution of wealth? How best may the resources of the rich be used to bring lasting social justice for all? Daisy, Countess of Warwick, offered an answer to this, and she remains one of the most fascinating characters in the history of philanthropy. Did you know that the British Welfare State possibly had its roots in Warwick Castle? Of all the many personalities who have lived in Warwick Castle, Daisy was outstanding: flamboyant, beautiful and compassionate. Of Daisy it was said (by author Anita Leslie, a cousin of Winston Churchill, in her book *Edwardians*

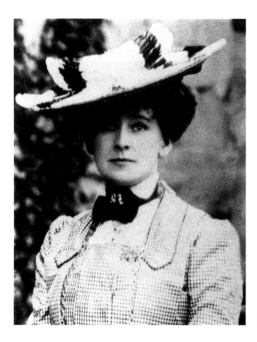

Daisy, Countess of Warwick.

*in Love* published 1972): 'She invented the Welfare State – and tried to run it out of her own purse.'

By the time Daisy had come to live in Warwick Castle in 1893 with her husband, formerly Lord Brooke, now the Earl of Warwick, she was already at the very heart of Edwardian courtly love games, and a favourite of the Prince of Wales, later to become King Edward VI. Troublesome rumours had swirled around her over the interference by the infatuated Edward in the matter of Daisy's lover Lord Charles Beresford and an indiscreet letter written by Daisy to Lord Charles' aggrieved wife Mina. Daisy had been in danger of losing the game whose first strict rule was 'There shall be no scandal' and whose penalty was 'Social Banishment'. Daisy had sailed through, loved by all for her charm and charisma. She combined beauty and extravagance with a kind heart and a philanthropic passion. As soon as she and her husband 'Brookie' had come to Warwick Castle, the exquisite young countess became a trustee of the workhouse, regardless of the disapproval of those who adhered to the strict social divide of the times.

Continuing her special friendship with the Prince of Wales, Daisy 'improved the tone' of the prince's life and made every effort to awaken in him a conscience for those who lived in poverty and deprivation. A year after their arrival at the castle, the Earl and Countess of Warwick gave a lavish ball at which everyone dressed in eighteenth-century court dress, and Daisy could indulge her taste for extravagant gowns. Afterwards, Daisy read a bitter attack on her in *The Clarion*, one of the radical newspapers to which she subscribed. She went to London to complain to Robert Blatchford, the editor, and declare her high-minded motives. She then listened to his scorching rebuttal of her views

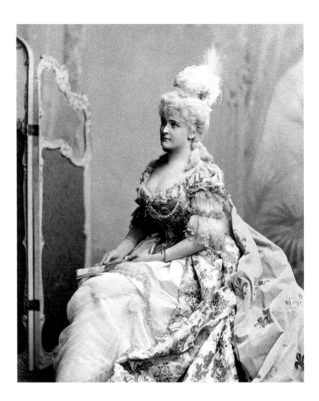

Daisy, Countess of Warwick,
in extravagant ballgown.

on how best to support the working classes. What she heard in his office had a profound impact on her. She spent the next few years in a whirl of philanthropic projects for social reform in her role as Lady Mayoress. She funded many of her schemes herself, recklessly reducing her finances. 'Eventually her huge fortune was dispersed in philanthropic schemes.'

Daisy's activities in the year of Queen Victoria's Diamond Jubilee included entertaining 2,500 schoolchildren and 100 civic guests at Warwick Castle and editing the memories of Joseph Arch, a former plough boy who had become England's most forceful attacker of class. Joseph Arch is commemorated here in a pub at Barford.

She played a large part in the two-year propaganda campaign that pressed for free school meals. She also campaigned for the school leaving age to be raised to sixteen. It was this campaign which enabled the Liberals to initiate free meals and medical inspection of schoolchildren when the party came to power in 1906, whereupon they introduced the Welfare State. Through her actions Daisy became living proof that people considered 'lost souls' can have their lives transformed if they are made to feel that they matter.

Daisy Warwick in her fabulous gowns, trying so hard to make the world a happier place, will be remembered in human history when the names of her dour opponents are long forgotten.

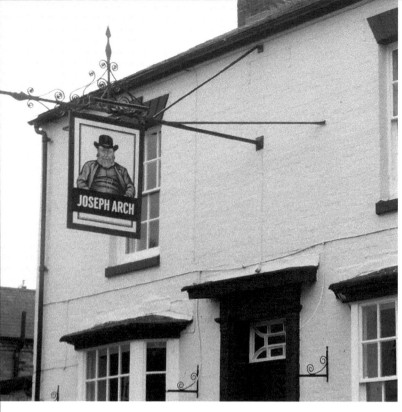

*Left*: Joseph Arch portrait on the pub sign at Barford. (Courtesy of Jamie Robinson)

*Below*: Joseph Arch pub at Barford. (Courtesy of Jamie Robinson)

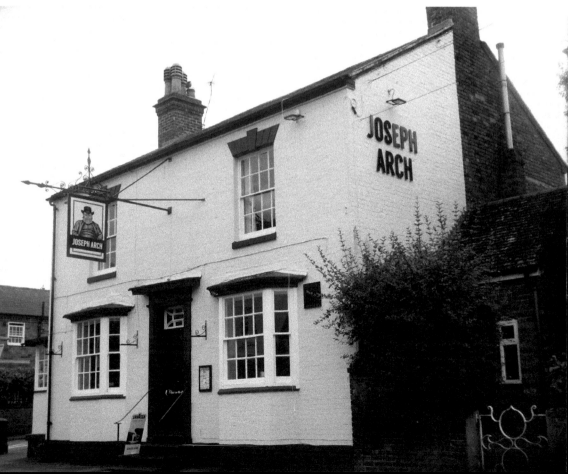

## Larry Grayson: Well-loved Twentieth-century Entertainer Celebrated in Nuneaton

Sometimes celebrities, authors and renowned figures in the arts and entertainment industries are proudly claimed by their hometowns, and sometimes not; it all depends on their own relationship with the community in which they grew up, and how it informed their later success.

In the case of Larry Grayson (1923–95), popular twentieth-century entertainer and television personality, he was well loved by many, including those closest to him, his family and friends. He is celebrated in a special exhibition in the Local History Gallery in the Nuneaton Museum and Art Gallery, Riversley Park.

He was born William Sully White in Banbury, Oxfordshire, to a young woman called Ethel who had become pregnant out of wedlock, at a time when society laid harsh judgements on unmarried pregnant women. As a small baby he was adopted by coal miner Jim Hammonds, his wife Alice and their two daughters, who lived in Abbey Green, Nuneaton. Jim's two daughters also worked in the coal-mining business, at Haunchwood Pit. When Larry was six, Jim died, and his foster sister, Flo (whom he always knew as 'Fan'), was given the task of bringing him up. Larry remained devoted to Fan for the rest of his life. He was known as Billy by his family and friends.

Nuneaton Museum and Art Gallery. (Author)

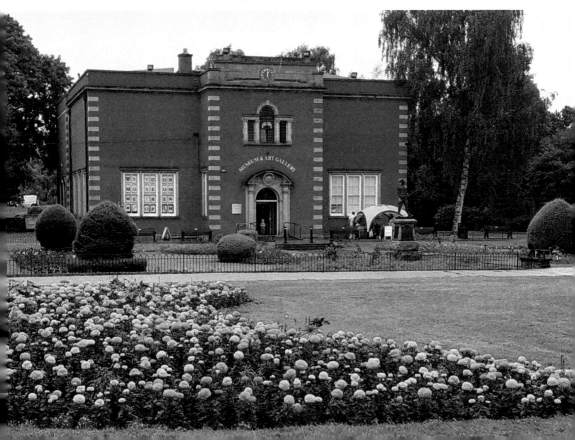

At Abbey Green School in Nuneaton, he performed to the other pupils, displaying his gifts as an entertainer. He left school at the age of fourteen and began working professionally on the comedy club circuit under the stage name of Billy Breen. Touring working men's clubs and variety shows across the country for the next thirty years, he developed a very popular act that consisted of gossipy banter of the sort one might exchange with a neighbour over the garden fence, picked up from his years of observation and listening to the people in his community. He created a cast of characters including his imaginary 'close friend' Everard, Apricot Lil from the local jam factory, Slack Alice the coalman's daughter, Self-Raising Fred the baker, and Sterilised Stan, the milkman.

In the early 1970s, agent Michael Grade saw his club show and signed him up to television work. He was soon given a thirty-minute sketch show, *Shut That Door*. He quickly caught the imagination of the television viewing public, and in 1972 he became Show Business Personality of the Year. In 1978 Larry was cast as the host of the popular Saturday night television programme *The Generation Game* alongside Scottish singer Isla St Clair. The programme was watched by over 18 million people each week and rose at one stage to 25 million, the highest ever audience for the show.

In the pilot for the show, Larry observed to the camera, 'Everard is pleased I'm on The Game at last.' Larry had true clowning skills; his demeanour was innocent and vulnerable, yet his gentle innuendo captivated audiences. His skill lay in that moment of engagement with the audience, the look at the camera, the glance to the side and then back again. His public adored the sense of vulnerability about him, getting things wrong and making it part of his act.

Now a national celebrity, back in Nuneaton Larry was persuaded to move with Fan from Clifton Road to a large house called 'The Garlands' in Hinckley Road. His Rolls-Royce could often be seen in the driveway. However, naturally a humble, unassuming person, he had only bought the mansion after persuasion; likewise, the succession of Rolls-Royces.

Clifton Street, Nuneaton. (Courtesy of Jamie Robinson)

The Garlands,
Hinckley Road,
Nuneaton. (Courtesy
of Jamie Robinson)

His biographer Tony Nicholson says:

> For all his talent, fame and huge popularity, there was an inner fragility about
> Larry Grayson that made it difficult for him to cope with the pressure of stardom.

Larry hosted the show between 1978 and 1982 and he left while the show was at
the peak of its popularity. Many have queried the wisdom of that decision: it may
well stand as the most ill-advised decision of his career. Following his departure
from the show, Larry assumed the BBC would offer him another big entertainment
vehicle, and they didn't. Comedy tastes had moved on and Larry's gentle innuendo
went right out of fashion. Larry had a few more television engagements, then
retired to Torquay with Fan. But after three years there, they headed back to
Nuneaton where Larry bought two bungalows for himself and Fan.

Friends and family members attest to his warmth and good nature. His
great-nephew Mike Malyon offers this memory of Larry in the local pubs:

> In the Hollybush and the Nag's Head … he would make us roar with laughter,
> just talking about the neighbours, talking about things that had happened to
> him. He really was an incredible person because I don't think I was ever in his
> company where he didn't make me laugh.

Larry Grayson in performance.

Despite fragile health and no big TV hit in the years since he left *The Generation Game*, Larry appeared at the Royal Variety Show on 3 December 1994. He began well but stumbled in the latter part of his routine, appearing older, slower and unwell. On 7 January 1995, at the age of seventy-one, he died, to the shock and disbelief of all who knew and loved him, nationwide, and especially in Nuneaton. As the ITV Head of Light Entertainment said, 'He was a lovely man'. In one sense his story can be seen as a brief flare of national stardom, which began later than it should have done and ended too early.

He was buried alongside other family members at Oaston Road Cemetery. Larry is credited with having paved the way for later 'camp' comedians such as Julian Clary, Graham Norton, Paul O'Grady and Alan Carr. Without him their progress into stardom would not have been so easy. With their offbeat humour, they have themselves acknowledged their debt to Larry. Fellow broadcaster Chris Tarrant said of him: 'If he had stayed the course, he would by now be a national treasure.'

## Cyril Hobbins: Traditional Wooden Toymaker, a Real Life Geppetto for Disney's *Pinocchio*

The image of a traditional wooden toymaker conjures for many the idea of the character of Geppetto in the story of *Pinocchio*. Cyril Hobbins of Kenilworth, born in 1938, describes how his love of wooden toy making began.

> As a child in the war, my experience was that we never had toys, so we had to make our own ... I can see us heading back to the 1950s, when things like spinning tops, hoops, cup and balls, and bow and arrows, were popular.

Cyril began his career as a carpenter and joiner, going on to work as a social services manager. He helped students to make toys as part of his work for social services and it became his passion.

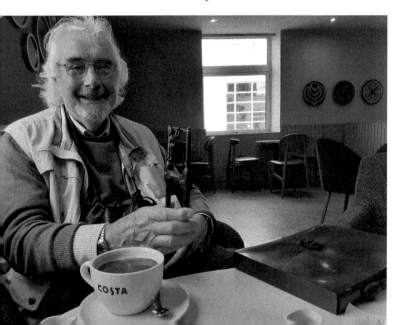

Cyril Hobbins in Kenilworth in 2021. (Author)

I wanted to do something creative that would last. Since I began this work, I've been very happy, and I've never grown up.

Alongside his role as a craft instructor for Social Services, he also worked as a set designer/painter for the Talisman Theatre and the Priory Theatre in Kenilworth, and for the Lockheed Pantomime Company.

Eventually in 1988 he chose to leave his full-time job to start up his own cottage industry, following his passion for researching and making traditional wooden toys and games. Cyril was to become an iconic figure in the world of traditional crafts. During his fifteen or more working years as a toy researcher, recreator, teacher, and demonstrator, he worked with thousands of children across the Midlands and Cotswolds. He travelled to craft events and local holiday activity events, and also to village schools in his Volkswagen campervan, sometimes staying overnight in playgrounds if working with all the year groups. He was one of the craft instructors at four international Guide Camps.

Other places Cyril visited to run toy-making demonstrations and workshops include Wellesbourne Watermill, Kenilworth Castle, and Compton Verney. He was official Tudor Toymaker for English Heritage, and worked in castles and stately homes, often dressing in full Tudor costume. Here he is shown at the British Waterways Day 1997, where he gave a workshop making wooden canal boats.

During my workshops in schools, every participant was guaranteed a working wooden toy within thirty to forty minutes. I used to offer a maximum of forty toys per day. I often wonder how many of my small charges still have their precious wooden toy? I was also a regular demonstrator at local woodworking shows and again. It was really hard work, but I loved every minute of it.

Many Warwickshire museums and art galleries now display Cyril's hand-crafted and painted toys, faithful replicas of those used in the past. These include St John's House Museum, Warwick; Compton Verney Folk Art Galleries; Ann Hathaway's Cottage, Shakespeare Birthplace Trust in Stratford-upon-Avon; and Charlecote House National Trust.

In 2008 Cyril was discovered by Disney as a 'real life Geppetto', and they approached him to ask if he would appear as an example of a real-life woodcarving toymaker.

Cyril says:

I had an email from Disney Home Entertainment. 'Would you be interested in helping us with Pinocchio?' I was very suspicious. 'This can't be right. Disney? Hollywood?' So I checked up on them and they were real: Disney Inc. They said they were asked to get in touch with me to see if I'd be willing to help them with Pinocchio. Within a week I'd got a film crew from Pinewood Studios, was getting paid by Disney and you can see the result on YouTube.

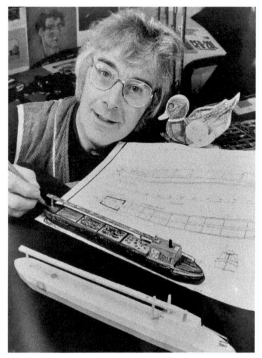

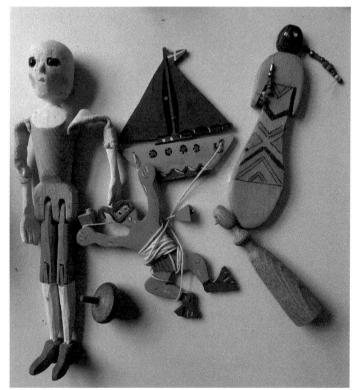

*Above left*: Cyril Hobbins at the British Waterways Day, 1997. (Image supplied by Cyril Hobbins)

*Above right*: Letter from child to Cyril Hobbins. (Image supplied by Cyril Hobbins)

*Left*: Selection of toys from Cyril Hobbins's current work-in-progress in 2021. (Author)

The sequence Cyril refers to appears in the Extra Features on Disney's remastered version of the classic animated film *Pinocchio*, released in March 2009.

Although now retired, at the age of eighty-three, Cyril is as creative as ever.

> I do photography and painting. I still pop into my workshop to turn something on my lathe, or to have fun making quirky windmills, beautiful little boxes, jewellery and whirligigs. Also, in retirement, I am researching: essentially my interest is unusual toys. It can even be something I have invented myself. It's ongoing. It never stops.

His book *Traditional Wooden Toys: Their History and How to Make Them* was published by Stobart Davies in 2009. Cyril's own collection of 500 wooden toys is now on display at St John's Museum in Warwick. Though he had offers from the Victoria and Albert Museum in London, he decided that he wanted to keep the collection in the county where his family has lived since the sixteenth century.

### Caroline Jones, Leamington Spa Hedgerow Healer: A Taste of Herbal Healing from the Centuries-old Tradition of the 'Cunning Woman'

Ritual and ceremonial gathering has long been an essential part of human life, certainly from Neolithic times. A significant number of people in our contemporary society, too, draw their inspiration from the deep wisdom of First Nation peoples, such as the Native Americans, the Maoris of New Zealand, the indigenous Polynesian people of Hawaii, and the Aboriginal Australians. The spirituality of all these peoples is deeply connected to nature, clearly seen in their rituals. In Leamington Spa, I met a lady who carries on these ancient traditions today in Warwickshire. Hedgerow Healer and ritual leader Caroline Jones says:

> First Nation peoples understand and honour our sacred connection to the natural world. The West merely sees resources and even people as material to exploit. Modern industrialised countries have lost all connection to and respect for the natural realm and are now living with the environmental and mental and physical health consequences.

Caroline leads rituals in various Warwickshire locations that are created by blending traditions from across the globe. A complementary therapist by profession, she offers several different therapies including Reiki and Crystal Healing. As a child, she says, she was described as 'a wild spirit of the woods' and by the age of four she was allowed to play alone in a local spinney for up to nine hours a day.

She was later encouraged by her family to follow academia, and ultimately became a journalist and BBC TV producer, co-presenting *Countryfile* with John Craven. She spent her time off tracking down global traditions and taking workshops with elders in Australia, New Zealand, South Africa, Hawaii, Japan,

A Warwickshire spinney. (Author)

China, India and extensively in Indonesia. 'Only South American Shamans remain on my enquiry list,' she adds. Caroline evolved into her ritual role of Hedgerow Healer through apprenticing at festivals and gatherings over the years.

The role of Hedgerow Healer has a resonance in the history of rural English communities, where women played a leading role, and the village cunning woman would be an expert herbalist. Such practices as 'camomile anointing', 'sage brushing' and the drawing of smoke from burning thyme on the fire are familiar parts of the ceremonies of a hedgerow healer today. The traditional 'hedgerow healers' would search among the local hedgerows and their gifts would lead them to the herbs they knew to possess healing properties. Confronted with a hedgerow cranesbill, they would see something to dig up to make a cure for their customers' haemorrhoids. Comfrey, growing wild, is widely used in some country districts, particularly Warwickshire, to make an herbal tea that is used to alleviate sprains.

The tradition of the 'cunning woman' is fascinating: archaeological finds support the idea that in former times women occupied a highly significant position in local communities akin to that of a priest. One such find, in the excavation of a Saxon settlement near Bidford-on-Avon Bridge, discovered a female skeleton with special grave goods which confirmed that she had been the local village cunning woman. The word 'cunning' means 'knowledgeable' in Old English. It is thought the tradition goes back to our Stone Age ancestors, whose

*Above*: Close-up of a Warwickshire hedgerow. (Courtesy of Jamie Robinson)

*Right*: Saxon Settlement plaque, Bidford-on-Avon. (Courtesy of Jamie Robinson)

*Below*: Bidford-on-Avon Bridge. (Author)

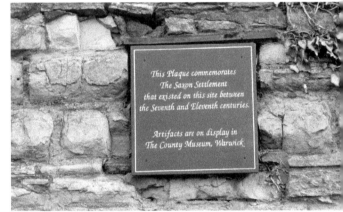

This Plaque commemorates
The Saxon Settlement
that existed on this site between
the Seventh and Eleventh centuries.

Artifacts are on display in
The County Museum, Warwick

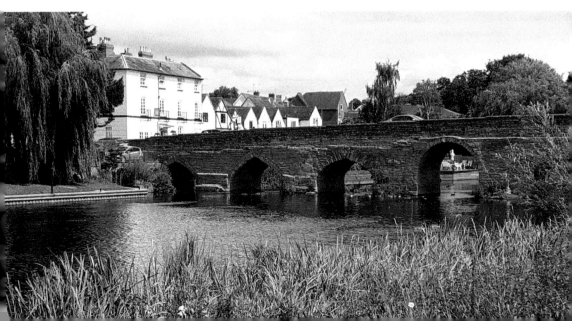

society was more matriarchal than many may imagine today. In these societies women took on the roles of intermediaries between humanity and spiritual powers. These women might also offer services such as counselling, healing and handfasting ceremonies.

Although Caroline would not lay claim to being a 'cunning woman' in every aspect of the ancient tradition, her use of hedgerow herbs in her healing rituals does resonate with these time-honoured practices. The rituals Caroline leads in modern Warwickshire involve the use of such healing herbs as wild sage and thyme.

> Burning sage remains a most effective healing ritual for spiritual ceremonies …
> our western culture most often pulls from the native American Indian practice of
> smudge sticks … in ancient smudging rituals, sage sticks were used ceremonially
> to cleanse the air … to balance the emotions and promote strong health.

Some of her circles are held in Foundry Wood, a much-loved local community woodland in Leamington Spa. Caroline says:

> Due to its wealth of natural beauty, many Warwickshire residents have a closer
> connection to nature. In Leamington Spa in particular, there are a large number
> of kindred spirits who enjoy spiritually connected respite from their day jobs
> and learning more of our ancestral truths.

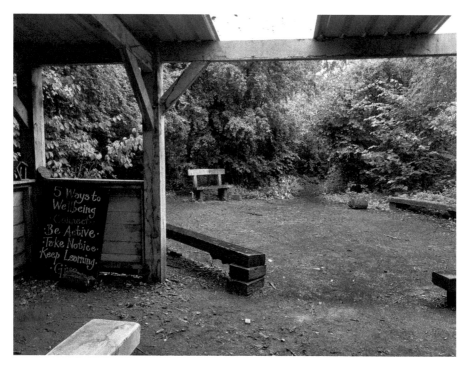

The clearing in Foundry Wood, Leamington Spa. (Author)

# 6

# Strange Happenings and Mysteries

Nay, 'tis strange, 'tis very strange, that is the brief and the tedious of it.
*All's Well That Ends Well* (Act 2, Scene 3)

## Big Cat Sightings and Paw Prints in Warwickshire

In British folklore, British big cats, also referred to as ABCs (Alien, or Anomalous, Big Cats), phantom cats and mystery cats feature in reported sightings of large Felidae in the British countryside. These creatures have been described as 'panthers', 'pumas' or 'black cats'. For several decades, people have reported sightings of big cats prowling around in the English countryside. Warwickshire is no exception to this.

At present the British Big Cat's status is similar to that of the Yeti: there have been sightings, photographs and films, including fakes and mistakes, but no firm evidence. Farmers and gamekeepers have seen 'leopard' tracks by carcasses of deer or livestock, and it is claimed that kills show characteristics of a big cat

Black Jaguar on the move.

kill rather than the work of dogs. A few sheep that escaped their attacker show distinctive leopard-like bitemarks.

Rick Minter of the Countryside Agency is a veteran of research into the phenomenon of Anomalous Big Cat sightings, and he interviews witnesses by means of some sagacious questioning. He has recorded 1,300 Anomalous Big Cat sightings in the UK over ten years, which may be found on his website 'Big Cat Conversations'. *The Times* of 29 August 2020 quoted him as saying he believes there could be a breeding population of about 250 black leopards and 250 pumas in the British countryside. However, other experts believe that it is extremely unlikely that any breeding population of non-native felines exists in the UK. That is also the official position of the British government.

One of the more recent sightings in Warwickshire was reported by angler Nigel Sweet at the Coalpit Fields area of Bedworth. His sighting was reported in the *Nuneaton News* edition of 27 August 2010. He was setting up his rods early one morning at a lake in the area when he became aware of a large, dark creature on the other bank.

> It was cat-like with a long tail and kept crouching down every few yards and looking around as if it had been startled by something. It looked thin as if it had had a rough time and was desperately looking for food. It wasn't trotting like a fox – it was stealthy and feline in its movements.

In 2018, a big cat sighting was reported on the golf course at the Ardencote Manor Hotel, Lye Green, Warwickshire. Kate Sanderson captured the animal on video, but a member of the hotel staff insisted it was just a big feral cat that prowls the golf course. As evidence, the staff member pointed out that the footage shows the creature prowling past a post which is known to be 3 feet tall; thus, the size of the creature can be ascertained, and it is merely a large feral cat, certainly not a panther or leopard.

The Warwickshire Museum holds in its collection the cast of a giant paw print. The resin cast was made of the print, which was dug from the mud after a panther-like creature was seen snatching a pheasant from Wasperton Farm, in Barford near Warwick, in November 2004. Wildlife experts said at the time that the sensational find was the most conclusive evidence yet that big cats were roaming Warwickshire. The print of the Beast of Barford was unveiled at the Market Hall Museum to coincide with the first national conference on Britain's big cats: the British Big Cat Conference, which was held in Marston Trussell, Leicestershire, in March 2006. At that time 1,200 sightings a year were reported in Britain, which, in Warwickshire, included sightings in Hampton Lucy, Wellesbourne and Oakley Wood.

The cast of the paw print is no longer on display at the Market Hall Museum, as in 2021, having been moved to make way for new exhibitions. Dr Jon Radley AMA, Curator of Natural Sciences at the Museum, says:

The cast, as displayed shortly after it was donated, is back in store. The display was designed to be temporary and was installed to reflect the local interest in the news story, at the time. However, I think it's still feasible that so-called 'big cats' could be living wild in the county, perhaps originally released from zoos, or escaped domestic pets. There's certainly plenty of wildlife around to sustain them.

## Boulder from the Ice Age in Stockton

The village of Stockton lies in the Stratford-upon-Avon district of Warwickshire and is notable for a curious landmark next to the village pump: a large boulder, which is rumoured to be a relic of the Ice Age. The lump of granite was found along the road to neighbouring Napton-on-the-Hill and identified in the 1880s by the then rector of the parish, Revd William Tuckwell, as a glacial boulder that the ice had carried down from the area of Mountsorrel in Leicestershire some 60 miles to the north. In 1882 Revd Tuckwell delivered a lecture on the boulder and its origins. The *Stockton News* said, in a November 2015 report:

Stockton village and boulder. (Courtesy of Jamie Robinson)

He showed that the Stockton Boulder must have come from Mount Sorrel in Leicestershire, a distance of sixty miles, in the arms of a glacier on an iceberg, at a time when this country, together with the whole of Europe as far south as central Germany, lay for ages buried in snow and ice.

Today, Mountsorrel Quarry is said to be the largest granite quarry in Europe. The rock still stands in the village street and is surrounded by metal railings.

Revd Tuckwell was known as the Radical Parson. A Christian Socialist, he believed in the nationalisation of land and divided up some of the Glebe (church) land into allotments for the villagers. Therefore, the Stockton Boulder may stand not only as a relic from the Ice Age, but also as a worthy memorial to this philanthropic man, which can still be seen today.

## Hirons' Hole at Littleham Bridge, Wellesbourne

In the village of Alveston you may find the Old Church with its atmospheric graveyard. Buried and commemorated there is one William Hirons, the subject of a curious Warwickshire tale.

One evening in November 1820 William, a yeoman farmer, was on his way home to Alveston from Warwick with a considerable amount of cash in his bag. He was set upon near Littleham Bridge, on the present day B4086 Wellesbourne Road, mugged and robbed of the money he had on him. Then he was left for dead. When rescuers arrived on the scene, they found him lying with his head resting in a hole. Those who discovered him tried to help but were unable to save him. However, before he died, he gave information that enabled the attackers

The Old Church of St James, Alveston, and churchyard. (Courtesy of Jamie Robinson)

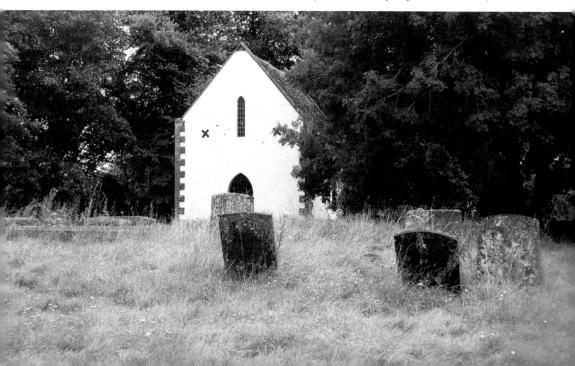

to be identified. Accordingly, the parish constable suspected a gang of four and arrested them. They were found guilty and executed. William Hirons was buried in the Old Church in Alveston, where a memorial tablet records the tragic event.

William Hirons was a popular employer in the area and well liked. After this tragic incident, the hole in which his head had rested started to gain a strange reputation. No matter how often it was filled in, within a few hours passers-by found that it had become a hole again. A tradition arose, which stated that 'the hole in which his head was found can never be filled up'. It became known as Hiron's Hole and locals avoided the area after dark. It was not until decades later that the truth behind the reappearance of the hole was discovered. The 'hoax' was the work of a group of William Hiron's former employees. They had emptied out the hole on their way to and from work, to mark the tragic incident.

The definition of a hoax is 'a humorous or malicious deception'. It seems that the employees may have first carried out this act as a curious kind of memorial to William Hiron. Their failure to inform any other members of the local community, and their realisation of the interpretation the community was putting on this, then led to it becoming a hoax. The residents had been quick to attribute a spooky character to the reappearance of the hole. In response to this, it seems William's faithful ex-employees had fed the innate tendency towards superstition in small rural communities, and were no doubt fascinated by and possibly even addicted to the sense of power it gave them, when they saw the local legend gaining strength, entirely through their agency.

The Old Church of St James, Alveston. (Courtesy of Jamie Robinson)

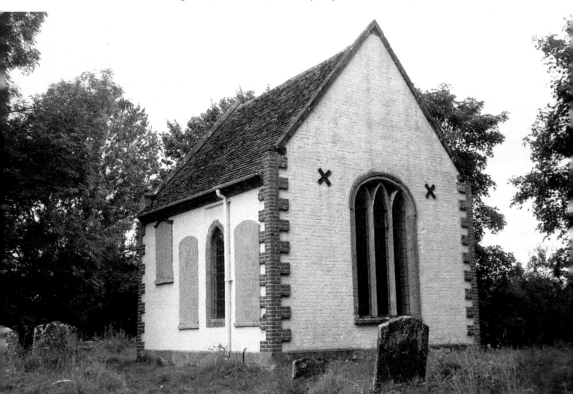

# 7

# Ancient and Not-so-ancient Legends, True or Apocryphal

> Go read with thee
> Sad stories chanced in the times of old.
> *Titus Andronicus* (Act 3, Scene 2)

## The Legend of Old Tom in Market Square, Warwick

The large timber-framed building at the corner of New Street and Swan Street near Warwick Market Square was built in 1634. On the corner you may see carved timber grotesque heads. Such grotesque heads would have been carved into buildings for special reasons, but a local legend suggests that in earlier centuries in Warwick, parents may have sought to gain control over unruly

*Above left*: Carved heads on house in Swan Street, Warwick. (Author)

*Above right*: Old Tom, carving on house in Swan Street, Warwick. (Courtesy of Jamie Robinson)

children by naming one of the grotesque heads 'Old Tom' and telling the children 'Old Tom' was looking down at them.

Another version of the legend asserts that Old Tom was carved to oversee the children playing in the market square, as their guardian. Following the death of some of these children, people began to claim they heard children playing on the top floor of the building. They then carved Old Tom higher up so he could watch over the ghosts of the children.

The third decade of the seventeenth century saw the construction of many completely new timber houses throughout the town. We may be curious to learn the real story behind the grotesque carved figures. According to Charles Fairey, historian:

> These devices, objects, symbols, graffiti or marks were thought to protect buildings and their occupants from evil entities, such as the Devil, demons, witches, fairies, etc. Whether day or night, these protective carvings, and their eternal watchful eyes, defend the occupiers and ward off the malevolence of the Evil Eye's gaze.

## The Apocryphal Legend of Charles I and Newton Regis

In the north Warwickshire village of Newton Regis you may find the medieval Church of St Mary the Virgin. St Mary's Church dates from the thirteenth and fourteenth centuries with a fifteenth-century porch. It has many interesting

Newton Regis. (Courtesy of Jamie Robinson)

features including a squint or 'leper window', the fifteenth-century gravestone of a priest and some fine stained-glass windows. The lychgate is also the village war memorial dating from 1928. It is part of the All-Souls' Parish of North Warwickshire. There has been a church here since at least the twelfth century.

The history of Newton Regis begins in the reign of Henry II (1154–89). Before that it was a part of the now smaller village or hamlet of Seckington. Newton Regis is not specifically mentioned in the Domesday Book, but it has been suggested that two and a half hides held in 1086 in Seckington correspond to present Newton Regis.

We may wonder how this tiny community gained the title of Regis. In fact the name commemorates the ownership by Henry II. An ancient legend attaches to the church: it states that Charles I prayed in the church on his way to battle. This story first appears in Arthur Mee's book *Warwickshire*, published by the King's England Press, 1936. Arthur Mee (1875–1943) was a British writer, journalist and educator. He is best known for *The Children's Encyclopaedia*, *The Children's Newspaper* and *The King's England* series of guides to British history and topography. Arthur Mee's source for the story is unknown. Historical researcher Caroline Smedley believes the story is almost certainly not true. Caroline has read

The Church of St Mary the Virgin, Newton Regis. (Author)

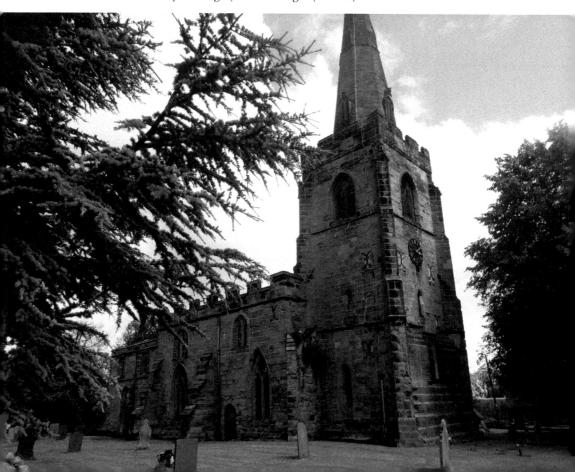

extensively about the Civil War period and has not found any reference to King Charles being anywhere near Newton Regis. She says:

> The only possibility is that a group of royalists could have been mistaken for a royal party, as they looked so grand.

A counter argument to this local legend lies in the existence of a memoir written in the early 1900s by Thomas Riley, who was born in Newton in 1847. He became headmaster and in 1903 published his history and memoir of Newton Regis. This includes his knowledge of earlier Newton history; for example, he quotes from Sir William Dugdale's book *Warwickshire* (published in 1695). However, he makes no mention of this rumour. It is certain he would have done had the rumour been current during the time he was compiling his book. There is also nothing in the church to suggest a reason for the story. Therefore, it remains a mystery as to where Arthur Mee got his information. It may even be a case of 'never let the facts get in the way of a good story'. Many legends of this type do persist in English history, and of course, there is always the chance that some of them may have elements of truth.

## The Assassination of the King of the Mercians at Seckington

Sometimes the legend is retold to include the information that Charles was on his way to the Battle of Seckington at the time. However, research reveals that the supposed Battle of Seckington happened in the eighth century if it happened at all, and that was hundreds of years before Charles I's time.

The village of Seckington is named as 'Secandune' in the Anglo-Saxon Chronicle. Historical sources state that this was the location of a battle fought between Cuthred and Ethelwald (sometimes spelt Aethelbald), King of the Mercians, in 757. In 757, Aethelbald was killed at Seckington, 'near the royal seat of Tamworth'. He was succeeded, briefly, by Beornrad. However, it seems this

Seckington. (Courtesy of Jamie Robinson)

'battle' may instead have been an assassination. Ethelwald's death is described in continuations of the *Historia ecclesiastica gentis Anglorum* in these terms: 'he was treacherously and miserably murdered in the night by his own guards.' The reason for this is unrecorded.

## The Story Behind Hangman's Lane, Seckington

In Seckington we may find Hangman's Lane and Hangman's Corner, on the crossroads from Newton to Shuttington, and Seckington to Polesworth. So how did this name come about? 'Right of gallows' is documented in nearby Newton Regis in 1285. Right of gallows has been defined as 'a privilege of the lord of the manor to hang criminals convicted by his court'. This applied to criminals who had been accused of theft and caught red-handed with the goods on their person. Nevertheless, there is no documented evidence of hangings at Hangman's Corner. Maybe hangings did take place there in the 'olden days' but it seems more likely to have been the site of a gibbet.

Caroline Smedley says:

Gallows and gibbet are sometimes used synonymously but while a gallows is a place of execution, a gibbet particularly means an upright post with a projecting arm that displayed the body of an executed felon – or a part of it – as a warning. To give maximum effect the gibbet was often placed on a hill or at a crossroads. I suggest this is what went on at Hangman's Corner. Dark and poky it used to

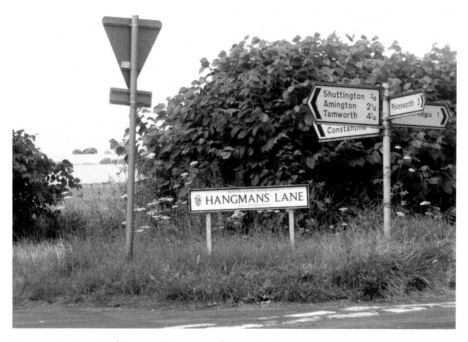

Hangman's Lane, Seckington. (Courtesy of Jamie Robinson)

be too, until a few years ago when its use by construction traffic demanded the removal of some of the trees.

The practice of displaying dead bodies in this way had ceased in most places by the later eighteenth century. Although in some places the practice lingered on for a few more decades, as can be seen by my story later in this book about the Gallows Healing.

## Guy of Warwick: Is He Buried at Guy's Cliffe?

Guy of Warwick is Warwick's tenth century legendary hero who killed the Dun Cow, and who after heroic exploits in the Holy Lands returned to Warwick and to the mysterious location later to become known as Guy's Cliffe. The first manuscripts (dated *c.*1225–50) that detail the story of Guy were written around the same time as the crusades, so it would be natural for the author to draw inspiration from contemporary events. The unknown author is clearly a Warwickshire local.

Much of Guy's story centres upon this area to the north of Warwick, now crowned by the ruined Gothic mansion set on cliffs to the north of Warwick beside the River Avon. Guy is said to have fought several fearsome creatures including giants, dragons, the Dun Cow, and the Boar featured in this sculpture. He undertook his adventures to win the love of Felice, the daughter of the Earl of

The house at Guy's Cliffe, seen from across the River Avon. (Courtesy of Jamie Robinson)

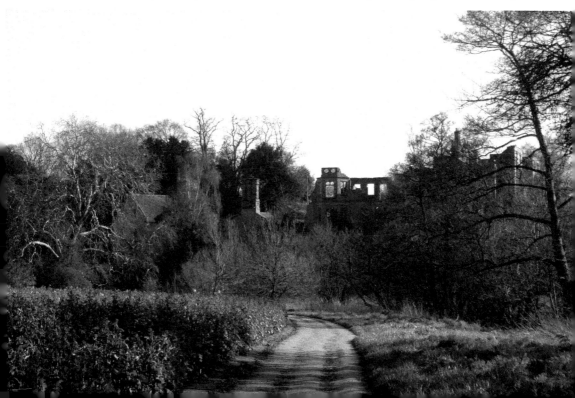

Sculpture of Guy of Warwick and
the Boar, Coventry Road, Warwick.
(Courtesy of Jamie Robinson)

Warwick. It seems Felice herself persuaded him: she commanded that he go and
become 'quite the best knight in the world' before she would return his love.

However, having won the heart of Felice, he spent only a short time with her
before departing for the Holy Lands to prove himself in several more daring
feats. He is then believed to have returned to Guy's Cliffe, where he inexplicably
chose to live for the rest of his life in one of the caves, before dying there. George
Evans-Hulme, local historian, writing for the *Leamington Spa Courier* on 30
August 2021, says:

> An interesting quirk in the story is that Guy requests to be buried in the spot
> where he died at Guy's Cliffe, to the extent that providential power prevents the
> first mourners from taking the body to be buried in Warwick.

The area of Guy's Cliffe has a charted history dating back to Roman times when
the secluded cliffs and water were a place of tranquillity and reflection. The
fortunes of the house (first built there by Samuel Greatheed, MP for Coventry,
in 1751) dipped after the Second World War, with the house and grounds
entangled in development and ownership wrangles. The core buildings returned
to regular use in the 1970s, with the Freemasons becoming tenants and carrying
out renovation work. In 1981 they took ownership from the then split estate of
Aldwyn Porter, Guy's Cliffe's former owner. But another blow came when flames
tore through the main house in 1992 while Granada Television used the ruins
to film an episode of Sherlock Holmes. In the aftermath, great slumps of debris
further obscured the rear of the house.

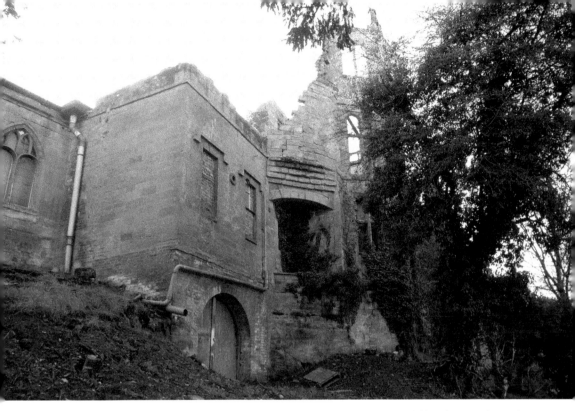

Slumps of debris obscuring lower parts of the house at Guy's Cliffe, showing buried archway. (Courtesy of Jamie Robinson)

The fabled cave where Guy of Warwick is said to have lived is an unremarkable hole in a base layer of sandstone rock. There's little fanfare about the Site of Special Scientific Interest; even its cliffs are obscured by undergrowth. This is changing, slowly. Adrian King, present custodian of the property, heads up the ongoing work through the local initiative 'Bring Back Guy's Cliffe', which involves a lot of heavy work clearing piles of debris that have built up around the historic ruins. He was asked about the legend that Guy himself may lie buried close to the mansion.

> We have dug as far as we possibly can into the history of Guy's Cliffe, and we have amassed many old images of the estate, but we've not completed our research.
> The tale is that Guy of Warwick was buried in the cavern that he lived in. Are there interments in that cave? Who knows? There may well be someone buried in the ground, but I don't think they will have been buried conventionally. All around the world there's evidence of civilisations that used underground systems … The cave may lead to a tunnel system: it may lead to a cavern. Until we remove the rubble from a lot of these places, we just won't know.

Mounds of earth under the skeleton of the former grand house are thought to have buried tunnels, chambers and rooms. The top of a grand arch can be seen at

the head of one escarpment underneath the austere stone facework of the manor. It is now hoped that the purchase of ground penetrating radar equipment will enable excavations beneath Guy's cave to discover at last whether any human remains lie there.

### Young William Shakespeare: Did He Really Get Caught Poaching Sir Edmund Lucy's Deer at Charlecote?

There can be no doubt that William Shakespeare would have known Charlecote, the grand sixteenth-century home of the Lucy family, and its rural parkland. But can we say that there were closer connections between Shakespeare and the Lucys? Legend has it that young William was caught poaching deer at Charlecote and was hauled up before the first Sir Thomas Lucy, the local magistrate. However, there is no documentary evidence for this, not even for the assertion that there was a herd of deer at Charlecote at the time. Scholars at the Shakespeare Birthplace Trust say there is also no evidence of any prosecutions for poaching, of anyone at all locally, during the years of Shakespeare's youth. Nevertheless, it may well be possible that he was, as a youth, caught poaching or misbehaving elsewhere and still brought before the authority of Thomas Lucy – but used his wit and way with words to escape punishment before his well-documented flight to London to escape further retribution.

Did Shakespeare caricature Sir Thomas Lucy as Justice Shallow in *The Merry Wives of Windsor*? Queen Elizabeth I's request for a play in which Falstaff falls in love led to a hastily written play for production at court where the audience

Charlecote House viewed across the park. (Author)

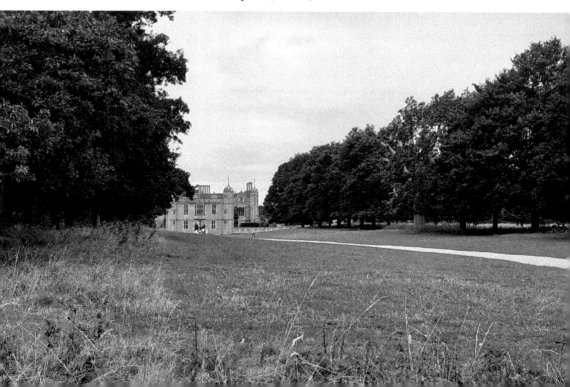

Deer in Charlecote Park. (Courtesy of Jamie Robinson)

would have recognised their colleagues being satirised. Justice Shallow is portrayed as a vain and fussy wealthy landowner, very proud of his ancestry, and there is much play on the word 'luce' (sounding like the derogatory 'louse'). The 'luce' (French: pike) from which the Lucy name derives is the fish symbol on the family coat of arms.

It is of course entirely possible that the poaching legend came about after the publication of *The Merry Wives of Windsor* when the links to Shakespeare's rural youth were spotted. Actor and impresario David Garrick organised the Shakespeare Jubilee festival in Stratford-upon-Avon in 1769, and for this event he helped revive the poaching story. No one knows how heavily embellished the legend became because of the Jubilee.

When actor, screenwriter and director Kenneth Branagh approached the Shakespeare Birthplace Trust during his research for the film *All is True*, based on Shakespeare's life, he too discovered that there is no documentary evidence for the poaching story. This was reflected in the scene where the older William Shakespeare is portrayed arguing with Sir Edmund Lucy. Sir Edmund taunts the playwright and his daughter, supposedly for lax morals, and William defends himself eloquently against Sir Edmund's arrogant, judgemental words. Then he walks away. A few seconds later he returns and says, 'I wish I did steal that deer from you.'

# Stories of the Supernatural

You are that shrew and knavish sprite
Call'd Robin Goodfellow.
*A Midsummer Night's Dream* (Act 5, Scene 1)

## The Crackley Wood Sprite, Kenilworth

Sightings of the Little People have persisted through the centuries in the British Isles; many are recorded in numerous books of folklore and the supernatural, and Warwickshire is no exception to this. In the past local villagers may have attributed difficult life experiences to the work of these supernatural beings. Many customs are rooted in the desire of our forebears to protect themselves from the spiteful activities of the fairies, and British folklore tells of intriguing anti-fairy measures to ward them off, like horseshoes over the front door, or the ringing of church bells, which, English folklore claims, fairies hate.

Crackley Wood. (Courtesy of Jamie Robinson)

However, fairies are not always thought of as malevolent. Sometimes one may strike a deal with a fairy and come out of the transaction on the positive side (rather like the tale of Rumpelstiltskin). A correspondent identified only as 'Chris' sent an email to the *Fortean Times* in October 2020 to report a strange sighting that happened to him in 2008. His piece was published on page 74 of edition 397 of the magazine.

Crackley Wood is an area of ancient woodland just outside Kenilworth, much loved by local ramblers and dog walkers, and renowned for its glorious bluebell displays in spring. Chris was inspired to send his account to the *Fortean Times* by another contributor, Paul Devereux, whose piece was published on page 55 of edition 393 of that magazine; namely, a story about 'the strange green figure' he saw 'while researching spirit paths in Ireland'.

Chris records that he was walking his dog on a cold, bright and slightly breezy day in early January.

> Suddenly, just a few yards in front of me, a very large, very loose ball of light brown dead leaves blew from among the trees on my right, across my path towards the trees on my left. It was moving much faster than I'd expect if it were being blown by the breeze. In the middle of the ball of leaves was a little man, dressed from head to foot in the same light brown shade as the leaves. He was about eighteen inches (forty-six centimetres) tall and running. As he (and the leaves) reached a tree on the left of the path, they all just vanished, as if they had gone into the tree. One moment they were there, moving very rapidly, then they were gone. Unlike Paul Devereux, I was alone; so, I have no one to corroborate my story, but I know what I saw. I also know it sounds mad, and this opinion has been confirmed by the reactions of the very few people I have told.

# 9
# Folklore and Folk Customs

Will you mock at an ancient tradition, begun upon an honourable respect, and
worn as a memorable trophy?

*Henry V* (Act 5, Scene 1)

## Border Morris, the Wassailing Ceremony, and Plum Jerkum:
## Warwick's Own Border Morris Side, Originating in Eathorpe

Wherever a folk festival is held, among the performers we may be sure to find
a Border Morris Side. Many love to watch the quirky, boisterous dancing, with
the compelling rhythm of their stamping feet and clashing sticks, and to see the
outrageous costumes and headgear.

The annual Warwick Folk Festival sees a colourful variety of performances
from eccentric dancers, singers and musicians. Warwick has its very own mixed
Border Morris Side, known as Plum Jerkum, whose members practise on a weekly
basis on Monday evenings in a local Warwick church hall. They can be seen at
multiple annual performances, and appear at the Warwick Victorian Evening, the
Alvechurch New Year's Day celebration, the Upton and Warwick Folk Festivals,
and the Welford-on-Avon Street Fair, to name just a few of their engagements.
Plum Jerkum dancers also do an annual Wassail tour, in which their task is to
drive demons from the trees to promote a good harvest. Wassailing is a Twelfth
Night tradition that has been practised in Britain for centuries. It has its roots in
a pagan custom of visiting orchards to sing to the trees and spirits in the hope of
ensuring a good harvest the following season.

Group leader of Plum Jerkum, Allan Smith, explains the ceremony in these
terms:

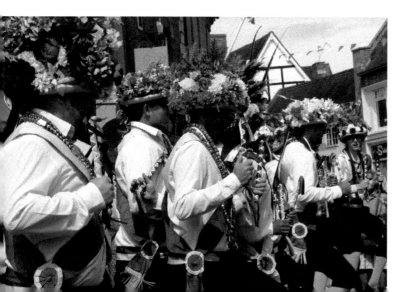

Morris dancers
during the Warwick
Folk Festival
in Smith Street,
Warwick. (Courtesy
of Abigail Robinson)

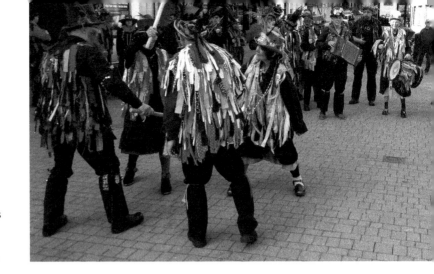

Plum Jerkum at Wellington Border Morris Day in 2018. (Courtesy of Plum Jerkum)

We dance at the start of each year to wake up the fruit trees. We make a lot of noise to frighten away the bugs and beasts. Then we hang toast on the branches, and that attracts birds who'll do their bit by eating any bugs that are left.

In Long Itchington, the dancers from Plum Jerkum make their way through the village dancing and singing for a large audience at five pubs: The Duck on the Pond, The Malt Kiln, The Country Store, The Harvesters and the Green Man. The performances incorporate music and dance and are part of an ancient pagan ritual to ensure a good harvest for local farmers. The wassail is said to scare off evil worms and maggots that may mar a good cider apple harvest and encourage good spirits instead. The ceremony used to be mainly for apple trees but in Long Itchington, plums were the focus of the ceremonies.

Long Itchington. (Courtesy of Jamie Robinson)

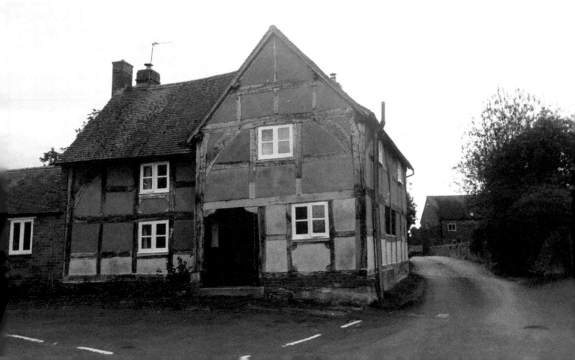

Border Morris originated in the counties close to the England/Wales border, mainly Worcestershire, Herefordshire and Shropshire. In the 1800s, seasonal workers danced to collect money in the lean winter months, and they 'blacked up' so they would not be recognised by their employers. These days, the dancers and musicians no longer paint their faces, but still retain their colourful costumes, each of which has a dominant colour theme different from everyone else. Dave Hutchins of Plum Jerkum says:

> People like to remember the past, when it is thought that life was much simpler (and harder, too, although people forget that). Border Morris is a celebration of working people, who had to wear costumes and disguises to dance for money, which was apparently illegal at the time.

Plum Jerkum were formed in 1986 by Max and Rose Smith as a mixed Border Morris Side and were based in the village of Eathorpe. The name of the troop originates from a local plum cider, made from the Warwickshire Drooper, which used to be much more common in Warwickshire hedgerows but is still present in places. It can be bought as a tree for gardens: Dave Hutchins tells me he has one

*Left*: Plum Jerkum at the Welford Street Fair in 2019. (Courtesy of Plum Jerkum)

*Opposite*: Eathorpe. (Author)

in his allotment and usually brews the Plum Jerkum so it may be drunk by all who attend the wassail. The Warwickshire Drooper is a large yellow plum which produces a beautiful colour of cider and has a characteristic taste that is very different to apple cider. It is reputed to affect the legs before any other part of the body feels ill effects. The casual observer must decide for themselves whether this in any way influences their style of dancing! Plum Jerkum is known for the 'big band' of which everyone is a member.

Their first dance out was at the Plough Inn, Eathorpe, in September 1986. I asked Dave and Pippa Hutchins of Plum Jerkum why these ancient traditions based in our national folklore are still so vibrant and alive in our modern society. Pippa says: 'In a multicultural world some of us like the idea of carrying on our ancient traditions to reinforce and express our roots.'

Dave says he was originally drawn to the group by a desire to play the melodeon.

This is one of the instruments most commonly played these days for Morris dancing, along with accordions, concertinas, fiddles and whistles. I had been interested in learning this instrument because of the famous folk/rock album 'Morris On' released in 1972, which helped to accelerate the 'folk revival' of the '60s and '70s. I now play the music and dance: the dances, too, have their own very interesting history.

Although not currently a member of the group, Pippa recalls how she enjoyed

> learning new dances, the music, the great aerobic exercise, the camaraderie, and the sense of fun performing in costume, in disguise.

Dave says that he has learned much more of

> the histories and tunes that have been played for many generations. It helps that Morris dancing is always watched by an audience, often in pub car parks, and it always seems to bring a smile to the faces of the people watching!

Border Morris wasn't always seen as a quaint anachronism; sometimes it found itself as part of the political and religious battles of the time. In the Easter 1655 Quarter Sessions can be found an order suppressing maypoles at Henley in Arden. Here, Morris dancing is considered:

> a heathenish and unlawful custom ... the observation whereof tendeth to draw together a great concourse of loose people and consequently to the hazard of public peace beside other evil consequences.

It was not of course specifically Morris dancing that was the issue. The ban was part of a Puritan clampdown on such customs as a whole – they were seen as the work of the devil, and pagan in origin. As such, as part of the Puritans' struggle for control of the church, they believed the custom should be banned. The sinister, dangerous association of folk customs with Paganism has been played upon successfully to the present day, with films such as *The Wicker Man* (1973) reinforcing this impression.

## The Story of the Dun Cow, Mythic Beast

In the village of Dunchurch, you may find The Dun Cow pub. So what creature is this? Local folklore tells us that the Dun Cow originally belonged to a giant in Shropshire, and gave milk freely from its seemingly inexhaustible supply to all who needed it. One day the cow was milked dry by an old woman who milked the Dun Cow into a sieve. Enraged, the Dun Cow, a monstrous, red-eyed beast, broke free and set off on a rampage, arriving in Dunsmore Heath and wreaking havoc, until killed by Guy of Warwick. It is possibly the Dun Cow may have been a rogue elephant, who were no strangers to British shores; elephants were present in Henry III's menagerie in the Tower of London in 1255.

Throughout the centuries of their castle ownership, the successive Greville Earls of Warwick liked to show off a colourful collection of artefacts and supposed relics, which they would display to their visitors, and each artefact would serve as the focus of a story. Whether or not the story was true, and the artefact genuine, was not a matter of concern to them: it impressed their visitors.

*Above*: Dun Cow pub, Dunchurch.
(Author)

*Right*: Dunchurch. (Author)

Therefore, the castle used to boast among its collection 'the rib of the Dun Cow', which was in reality a whale bone. The story of the Dun Cow took pride of place at the Warwick Pageant of 1906. The Warwick Cup (now on display in the State Dining Room), featuring a silver figure of Guy of Warwick on horseback killing the Dun Cow, was presented at Warwick Races in 1854.

## The Story of the Mickleton Hooter That Roams Meon Hill

Warwickshire folklore records the story of a ghostly creature that was reported to roam near Meon Hill and became known as the Mickleton Hooter. The village of Mickleton is in Gloucestershire, but Meon Hill is in Warwickshire. The phenomenon acquired this name because 'Hooter' is an Old Warwickshire word for a ghostly hound. A cluster of stories about lone supernatural black dogs are associated with Meon Hill and the surrounding areas.

One story tells of a mysterious coach pulled by six horses and accompanied by a pack of hounds, seen heading for the Gloucestershire border late at night; this story was told by residents of Ilmington to a folklore researcher in the early twentieth century. Another legend concerns a ghostly huntsman and hounds on the hill, and the reports of phantom black dogs have been recorded from Little Compton, Radway Grange, Snitterfield and Warwick. Such dogs are believed to haunt boundaries, roads, wells, and places where people have met violent deaths. They have also been spotted at prehistoric sites. Meon Hill had an Iron Age camp

*Above left*: Meon Hill. (Author)

*Above right*: Ilmington. (Courtesy of Jamie Robinson)

*Below*: View across the border of Warwickshire to the village of Mickleton, Gloucestershire. (Courtesy of Jamie Robinson)

built on its summit. Whether the strange noises of the Mickleton Hooter emanate from a single ghostly black dog or a pack of spectral hounds, the area around Meon Hill, with its prehistoric past, has an eerie reputation.

## The Story Behind the Bear and Ragged Staff

In many places in Warwickshire we may find the image of the bear and ragged staff. It has long been the heraldic emblem or badge associated with the Earldom of Warwick. It is a popular name for pubs and may be seen on the main gates of the Old Shire Hall and Judges' House in Northgate Street, Warwick, and here at the Lord Leycester Hospital in Warwick.

How did this heraldic motif originate? What does a bear have to do with Warwick? It is thought to have derived from the name of an early legendary Earl of Warwick named Arthal, which signifies 'a bear'. In *Antiquities of Warwickshire* by Sir William Dugdale, published by William Caxton in 1695, we may find this account:

> About this time it was that the famous Arfal lived ... the 1st Earl of Warwick ... who took the Bear for his ensign, which so long continued a badge to the succeeding earls. The next of these British Earls ... Morvidus ... slew a mighty Giant in a single Dual; which giant encountered him with a young Tree pull'd up by the root, the boughs being snag'd from it, in token whereof he and his successors ... bore a Ragged Staff of Silver in a sable shield.

The Bear and Ragged Staff pub, Kenilworth. (Author)

The Bear and Ragged Staff emblem on the gates of the Old Shire Hall and Judges House, Warwick. (Author)

The Bear and Ragged Staff emblem at Lord Leycester Hospital, Warwick. (Courtesy of Abigail Robinson)

# Famous Individuals Not Usually Associated with Warwickshire

Find what you seek,
That fame may cry you loud.
*All's Well That Ends Well* (Act 2, Scene 1)

## J. R. R. Tolkien, Creator of Middle-earth: Inspired by Warwickshire and by the Town of Warwick

The fully realised vision of the great fantasy writer J. R. R. Tolkien, which emerged in his most popular works *The Hobbit* and *The Lord of the Rings*, arose from a rich blend of his experiences, relationships, and inner life from earliest childhood through adolescence and into adulthood. For the most part, no single element of his creation, Middle-earth, can truly be said to have emerged solely from a single source. Nevertheless, he is known to have told his publisher 'The Shire is more or less a Warwickshire village of about the period of the Diamond Jubilee.'

That refers to Queen Victoria's sixtieth year on the throne, 1867. More commonly associated with Oxford and Birmingham, it is not widely known that Tolkien was inspired by the Warwickshire countryside and specifically by the town of Warwick itself.

Having spent his infancy in South Africa and his childhood in Birmingham, John Ronald Tolkien married his bride Edith in Warwick, at the Church of St Mary Immaculate in West Street, on 22 March 1916. While Tolkien and his

Blue plaque on the Church of St Mary Immaculate, Warwick, commemorating the marriage there of J. R. R. Tolkien and his bride Edith in 1916. (Courtesy of Jamie Robinson)

The Church of St Mary Immaculate, Warwick. (Courtesy of Jamie Robinson)

family called Sarehole, in Birmingham, their home, Edith lived in lodgings in Warwick for a while immediately prior to her marriage. Edith shared her home with her cousin Jennie and received instruction in the Catholic faith from Father Murphy, parish priest of Warwick.

The elements of Warwick so attractive to Tolkien can be detected echoing in his works throughout his life. Tolkien's foremost biographer Humphrey Carpenter also notes that during the late sixties, Tolkien's residency in the town was celebrated, and 'students at Warwick University renamed the Ring Road around their campus "Tolkien Road"'.

The beauty of Warwick in former times was especially significant in relation to Tolkien's scholarly interests as professor of Anglo-Saxon literature. Anglo-Saxon Warwick, on its rocky outcrop, commanded a crossing on the River Avon. We know that Tolkien admired the stone-built castle on its rock rising above the river, commanding a lofty position from which a wide panorama can be seen. This became a model for Middle-earth locations such as Minas Tirith. Tolkien's

A view across Warwick from the battlements of Warwick Castle. (Courtesy of Abigail Robinson)

early poem 'Kortirion Among the Trees' was written in Warwick during army leave in autumn 1915, when Tolkien's peers were beginning to be cut down on the battlefields of Europe. In this poem he evokes a fading town overshadowed by towering elms, which was built by elves on a hill close to a river, and it contains what were to become some of his most characteristic themes. He suggested within his vision that it was no longer the dwelling place of elves as its ancient mythical beauty had waned. Nevertheless, Warwick's remaining beauty and importance to his personal life was such that he dedicated his poem to the town and returned to its image again and again in his writing throughout his life.

## Sir Thomas Malory of Newbold Revel: Author of *Morte d'Arthur*

Some of our greatest authors wrote their most memorable works in prison. To their number we may add Sir Thomas Malory (1405–71), who is responsible for giving the legend of King Arthur a sensational new telling for different darker times. It was published posthumously, after the War of the Roses, in 1485.

The legendary King Arthur first appears in 1186, in the writings of Geoffrey of Monmouth. British journalist and writer Ian Hislop puts it like this: 'on the way through the centuries, Arthur got another upgrade at Glastonbury Abbey, and gathered a holy reputation along with the legend of the Holy Grail.'

It took Sir Thomas Malory to turn Arthur's story into an epic romance of betrayal, sexual intrigue and death. All the tragedy of that time was channelled into *Morte d'Arthur.* published by William Caxton in 1485. Sir Thomas's retelling was to become the basis for every subsequent Arthurian tale.

Sir Thomas was in and out of prison most of his adult life. His base was the manor at Newbold Revel, Stretton-under-Fosse. The name Newbold reappears throughout Warwickshire and the word 'bold' simply means a house, therefore Newbold Revel means the new house of the Revel family, who were the lords of the manor. The family of Revel may be traced down from Wappenbury to Revel to Malory, as mentioned on page 81 of *Antiquities of Warwickshire*.

Today, with supreme irony, the house is used as a Prison Service Training College; ironical because Sir Thomas Malory was often on the wrong side of the law. History records several of his misdemeanours. His criminal record includes a) conspiring with Richard Neville, Earl of Warwick, to overthrow Edward IV,

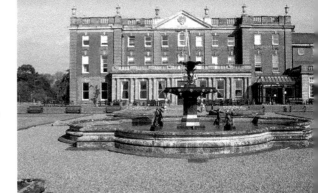

The manor house of Newbold Revel, now HM Prison Service Training College.

for which he was caught and imprisoned in June 1468; b) ambushing Humphrey, Duke of Buckingham, at Coombe Abbey; c) cattle rustling at Cosford; d) extortion in Monks Kirby; and e) rape in Coventry.

Perhaps Sir Thomas had a strange idea of how to be a Knight Errant. He apparently was described by Caxton at the end of *Morte d'Arthur* as a 'knight prisoner'. The Manor of Newbold Revel, originally known as Fenny Newbold, was acquired by the Revel family in 1235. It descended to Sir John Revel MP. On his death it passed to John's daughter Alice, who had married John Malory of Winwick, Northamptonshire. Their son was Sir Thomas Malory, the author of the Arthurian legends, who, we are led to believe, also served as MP for Warwickshire from 1443 to 1445. In those days a criminal record was no bar to serving as an MP. In fact, the concept of being an MP was radically different to ours – different rules applied. Sir Thomas's great-grandson Nicholas sold the property and it passed through a succession of private hands including the builder of the present house, Sir Fulwar Skipwith. In 1985 it was taken over by the Prison Service, thus completing an ironical story arc from the time of its former occupant, a career-criminal genius writer.

## Sarah Siddons: the Greatest Tragic Actress of the 1800s, Formerly a Lady's Maid at Guy's Cliffe, Warwick

Samuel Greatheed, MP for Coventry, purchased the land at Guy's Cliffe Warwick in 1751, on which he later built his mansion. He died in 1765 but his widow Lady Mary continued to live there and in 1771 befriended a young actress, Sarah, who had been sent to Guy's Cliffe to fill the position of lady's maid. Her father had sent her there to try and break off an unsuitable attachment.

The actress was Sarah Siddons, and she was later to star in many iconic stage roles, in famous theatres such as Covent Garden and the Theatres Royal in Drury Lane and Bath. She played Hamlet many times, and her Lady Macbeth was renowned, as was her performance as Queen Katherine in *Henry VIII*.

However, aged sixteen and seventeen, she served as lady's maid and companion to the widowed Lady Mary Greatheed at Guy's Cliffe, Warwick. Sarah became good friends of both Lady Mary and her son Bertie, aged twelve at the time of Sarah's arrival. This friendship continued and in future years Bertie Greatheed and his wife Ann were among friends with whom she would leave her children, during her lengthy provincial tours. Her natural poise, of such value to her in her acting career, was nurtured during the two years she spent in the elite Greatheed household.

Young Bertie, himself to become a dramatist, specially wrote his play *The Regent* for her and cast her in the starring role. Unfortunately, Sarah described the part Bertie had written for her as 'this milksop lady' and said of this role: 'unless he makes her a totally different character, I cannot possibly have anything to do with her'. Clearly Bertie forgave her because he renewed their acquaintance upon his return to London in 1786 after four years in Europe. Star-struck and attracted by

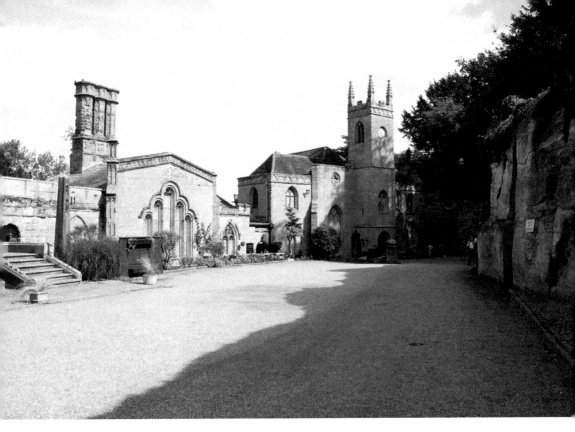

*Above*: The courtyard at Guy's Cliffe, Warwick. (Courtesy of Abigail Robinson)

*Right*: Actress Sarah Siddons in the role of Ophelia.

Siddon's celebrity, he frequently invited her to visit Guy's Cliffe, and she came to view it as a peaceful refuge during times of sorrow and illness in her life.

The friendship continued after Sarah's retirement, and during a month-long stay at Guy's Cliffe in July 1818 with her daughter Cecilia, she entertained them with daily play readings after dinner. Bertie commented that 'Mrs Siddons in the evening read the part of Constance in a way past all description fine.' And 'Mrs Siddons finished Macbeth in a most masterly manner.'

Social Historian Dr Susan C. Law made Sarah Siddons the subject of her thesis *Sarah Siddons, Bluestocking Actress*. Susan says:

> I think those two years spent at Guy's Cliffe had a subtle and lasting influence on her successful stage career. It gave her an early self-confidence and maturity, but also the chance to observe upper-class life at close quarters. No doubt she absorbed, quite subconsciously, all the nuances of genteel behaviour such as gestures, expressions, and tone of voice, that were invaluable later on when she played her signature roles of aristocrats and queens with such natural grace and dignity. Siddons was a fascinating character and I really admire her achievements as a pioneering role model for working women, who was determined to control her own destiny. She was a high-earner supporting her large family, at a time when most women were confined to domesticity, playing minor supporting roles to the men in their lives. Despite huge success, she had a refreshing disregard for fame, often yearning for a simpler and more peaceful existence in her country cottage, away from the demands of celebrity.

# The Ancient Forest of Arden

They say he is already in the Forest of Arden, and a many merry men with him.

*As You Like It* (Act 1, Scene 1)

## William Shakespeare's Magical Forest in the Region of Arden

The ancient Forest of Arden inspired both William Shakespeare and J. R. R. Tolkien. It provides the setting for Shakespeare's play *As You Like It* and exerted a powerful influence on the English imagination, not least inspiring J. R. R. Tolkien for The Old Forest in *The Lord of the Rings*. Shakespeare's Arden is a nostalgic, mythic version of the historical ancient Forest of Arden. Shakespeare used forest settings, sometimes magical, in many of his plays.

The English Forest of Arden stretched from Stratford-upon-Avon in Warwickshire to Tamworth in Staffordshire. Branches of the Shakespeare family lived in Arden villages such as Temple Balsall, Packwood, Baddesley Clinton and Snitterfield, and, of course, Shakespeare's own mother carried the family name of Arden. However, even as he wrote, Shakespeare was looking back to romanticized versions of the forest as it had formerly existed, covering a huge swathe of land, the haunt of bears and wolves, for during his life it was subject to deforestation and enclosure. Shakespeare's Arden gave rise to a view of the ancient forest that inspired English nostalgic visions and pre-Raphaelite artists.

The ancient Forest of Arden has now largely disappeared, but pockets of trees, field boundaries and several 'mighty oaks' proclaim the heart of the original forest. Here, Shakespeare's Arden can be glimpsed. Many of the remaining hedgerows are medieval, some perhaps a thousand years old. The presence of woodland indicator plants makes it possible to date the hedgerows: plants such as native bluebell, primrose, and wood anemone; and woody species including hazel and small-leaved lime.

In Warwickshire we may find Ryton Wood,

an ancient woodland that has been wooded since at least 1600 and has history going back to at least medieval times.

A spokesperson for the Warwickshire Wildlife Trust told me:

The fact that small leaved limes are present indicates the woodlands' age as they were once a very common species in woodlands but have since declined considerably.

*Above*: Ryton Wood. (Courtesy of Jamie Robinson)

*Below*: Ryton Wood showing sign for walkers. (Courtesy of Jamie Robinson)

Henley-in-Arden. (Author)

The ancient forest is commemorated in Warwickshire place names that end in 'ley' or 'leigh', which denote a clearing in the forest. Places such as Hampton-in-Arden and Henley-in-Arden remind us of their heritage in the ancient forest, which Shakespeare used as the wild setting for his imagination to roam.

## The Heart of England Forest, Inspired by Felix Dennis, Eccentric Entrepreneur at Dorsington

In recent years in the village of Dorsington, a visionary and eccentric wealthy landowner, Felix Dennis, acted on his dream of bringing native broadleaf trees back to the landscape by planting a 'joined-up' woodland that would provide vital green corridors for wildlife as well as a light and airy place for everyone to enjoy. As a poet himself, Dennis no doubt appreciated that the Forest of Arden was the setting for Shakespeare's comedy *As You Like It*. Felix planted the first small wood near his home in 1996. His vision was to plant at least 300 acres per year. The forest is mainly in South Warwickshire and stretches from the ancient Forest of Arden to the edge of the Vale of Evesham. Following Felix's death in 2014, many more trees have been planted. At the time of writing, just 23 per cent of the way towards their 30,000-acre goal, the Heart of England Forest is already the largest new native broadleaf woodland in England.

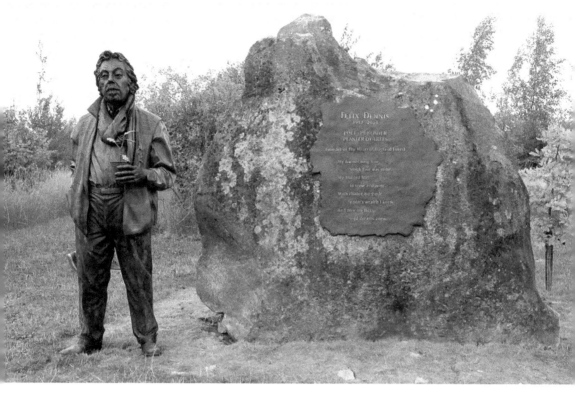

*Above*: Felix Dennis bronze statue at Founder's Rock in Heart of England Forest at Dorsington. (Courtesy of Abigail Robinson)

*Below*: Giddings Wood, part of the Heart of England Forest. (Courtesy of Jamie Robinson)

## The Saxon Sanctuary at St Peter's Church, Wootton Wawen, and Holy Trinity Church at Morton Bagot

In the same area we may find two historical locations: St Peter's Church, Wootton Wawen, with its Saxon Sanctuary, and the ancient hilltop church of Holy Trinity at Morton Bagot, in front of the site of an Iron Age fort. St Peter's Church, Wootton Wawen, contains the Saxon Sanctuary and here at Wootton Wawen there is rare evidence for the location of an Anglo-Saxon church predating the Norman Conquest. In the church you may find an exhibition about the colourful story of 'the village in the magical Forest of Arden'. The name Wootton means 'settlement in a wood'. Here in a clearing of the ancient Forest of Arden, Lord Wagen commanded his manor. The present-day village of Wootton Wawen takes its name from him as the Saxon thane who was lord of this farming settlement before the Norman Conquest. After the Battle of Hastings all Lord Wagen's lands were given by William the Conqueror to his friend Robert, the new Norman Earl of Stafford. What happened to Wagen is unknown, but it is thought he may have died at the Battle of Hastings.

On my visits to the church, I have been captivated by the exhibition, and by the Saxon Sanctuary itself, a highly recommended destination for those visiting Warwickshire. Nearby, Holy Trinity Church, Morton Bagot, is part of the Arden Marches group of churches, and it has a very special atmosphere. Three miles south-west of Henley-in Arden, and close to what little remains of the ancient Forest of Arden, this church may inspire those of us who carry myth and legend in our imaginations. When we investigate this church, we find that

St Peter's Church, Wootton Wawen. (Courtesy of Abigail Robinson)

*Above left*: Interior of the Saxon Sanctuary at St Peter's Church, Wootton Wawen. (Courtesy of Abigail Robinson)

*Above right*: The roof of the Saxon Sanctuary at St Peter's Church, Wootton Wawen. (Courtesy of Abigail Robinson)

*Below left*: Holy Trinity Church, Morton Bagot. (Courtesy of Abigail Robinson)

*Below right*: Churchyard of Holy Trinity Church, Morton Bagot. (Courtesy of Abigail Robinson)

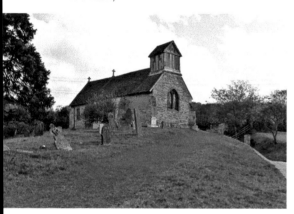

electricity and mains water have never intruded on the ancient stone. In the depths of winter, the candlelight is magical. The setting on a bank next to Church Farm is stunning. There are open views of the hills around, with an Iron Age fort clearly visible behind the church.

As you approach the church from the lane, you are presented with the vision of an ancient chapel on a hill. This is 'a natural bluff of Arden Sandstone'. The church is first recorded in 1253 and was surrendered to the bishop by its rector in 1292 as derelict. However, the east wall was subsequently rebuilt, and the west end of the nave extended in the fifteenth century. The south porch, tiled roof and bell turret date from around 1600. The ancient church on the hill has a strong spiritual resonance and arouses the imagination, enabling visitors to feel for a short while that they inhabit a time when the Forest of Arden flourished.

# Ancient Ceremonies and Strange Rituals

The people
Must have their voices; neither will they bate
One jot of ceremony.

*Coriolanus* (Act 2, Scene 2)

### Ancient Tax Gathering at Ryton-on-Dunsmore

Very early in the morning on 11 November each year a procession of people may be seen making their way along by the A45 near Ryton-on-Dunsmore. They all rise before dawn to meet at a stone in a field to observe a ceremony considered to be over 1,000 years old (and known to have been ongoing at the time of the Domesday Book). Each one of the participants is determined to:

acknowledge our shared heritage
in this not-quite-forgotten place.

The stone may be reached via a gateway into a field just off the A45 from Coventry to Rugby. This is the base of the medieval Knightlow Cross, which was probably destroyed in the sixteenth century. From here you may also enjoy a distant panorama across the fields to Coventry. For many centuries, it has been an important meeting place for the representatives of the villages of the Hundred

The base of the
Knightlow Cross
on Knightlow Hill,
Ryton-on-Dunsmore.
(Courtesy of Jamie
Robinson)

The view from Knightlow Hill across to Coventry. (Courtesy of Jamie Robinson)

of Knightlow, who come on the eve of Martinmas to pay their dues in Wroth Silver to the lord of the manor (who is currently Richard Scott, 10th Duke of Buccleuch).

It is believed that the ceremony has its roots in Anglo-Saxon times. Historical records confirm 1170 as the year the Wroth Silver ceremony first took place at Knightlow Hill, at which the dues were paid to the Crown. This feudal ceremony continued to be held by law throughout England until 1800. For fifteen years it went into abeyance and then the ceremony began to be observed again each year on Knightlow Hill in Warwickshire. Here, in the Hundred of Knightlow in 1629, the Rights to the Ceremony and Collection had been granted through Letters Patent by Charles I to Sir Frances Leigh of Newnham Regis, grandson of Sir Thomas Leigh of Stoneleigh Abbey. He purchased the Rights from the Crown for £40. In the nineteenth century, his descendent Lady Elizabeth Montagu married Henry Scott, 3rd Duke of Buccleuch. Her grandson Walter Frances succeeded to the Lordship of the Hundred of Knightlow in 1860.

Today, David Eadon continues a multi-generational line of those faithful to the Wroth Silver ceremony in Warwickshire. He first attended at the age of four in 1938 with his father Chris and his grandfather William; some of those present at that ceremony had attended it in the 1800s. William spoke at the Wroth Silver

breakfast following the ceremony each year up until 1950; Chris took over that duty until 1965; and David succeeded him in the following year. He has given the speech every year since then (apart from the Covid-19 pandemic year, 2020). In that year, though, five people did gather at the Stone. On 11 November 2021 I attended the ceremony on the 852nd known year that it has taken place at Knightlow Hill. David Eadon was present on this occasion for the eighty-fourth time in his life.

By tradition, the ceremony must always take place 'before sunrising'. Its timing has a historical rationale: it was the last possible moment to pay the tax. The first written record of the handing over of the Wroth Silver shows that in 1086 thirty-four parishes were called to pay a total of 11 shillings. At some point (we do not know the date) nine parishes ceased to be called. The remaining twenty-five parishes were called to pay a total of 9 shillings and 4 pence. The dues remained the same right up until decimalisation when they became 46p. In the fourteenth century it cost 10 shillings to buy a cottage, which means that the Wroth Silver dues were equivalent in value to £250,000 today. Dues were assessed on a 'per head of cattle' basis.

When I attended the ceremony together with a large crowd representing the parishes of the Hundred of Knightlow, the Mayor of Rugby, the Duke's Agent,

The Wroth Silver ceremony, 11 November 2021, on the mound of Knightlow Hill. (Courtesy of Jamie Robinson)

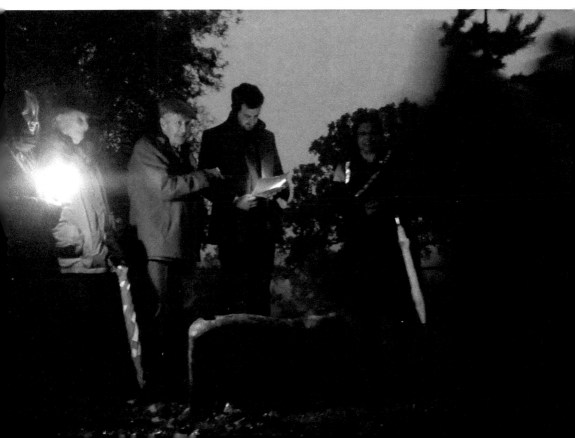

and others stood at the stone on the mound with David Eadon. The crowd waited respectfully around the base of the mound. The representatives of each parish came up when called and threw their coins into the stone with the cry of 'Wroth Silver'.

'Princethorpe! One penny.' 'Astley! A halfpenny.' 'Hillmorton! One penny and one halfpenny.' Then the name of Harbury was called out. 'Eleven pence and one halfpenny.' There was a collective drawing of breath at the large amount owed by Harbury. Long Itchington was the next debtor owing dues of 11 pence.

After the ceremony, everyone departs to the Queen's Head, Bretford, for the Wroth Silver Breakfast. For many years, the breakfast was held at the Dun Cow, Stretton-on-Dunsmore, but this pub no longer exists. Instead, it is here at the Queen's Head that all attendees enjoy breakfast and receive a clay 'Churchwarden's Pipe'. After the breakfast, we listened to a speech from the Mayor of Rugby and toasted the Queen and His Grace the Duke of Buccleuch in the traditional drink of rum and hot milk. Then we heard the bard for the occasion, Barry Patterson, give his rendition of this year's Wroth Silver poem: *Dear Ancestors*.

The poem ends with these lines:

> People of the land, following the path of life
> Should we be spurred by fear, anger, pity, shame or pain?
> Or by delight in the depth & richness, complexity & danger
> Of the life that we have inherited from you?

Next, we heard a speech from Sam Rees, the Land Agent from the Duke's Boughton Estate, who, along with a report on the farm estate, also announced

The Queen's Head, Bretford. (Author)

*Above*: The churchwarden's pipe and two glasses of rum and hot milk at the Wroth Silver breakfast, The Queen's Head, Bretford, on 11 November 2021. (Courtesy of Jamie Robinson)

*Right*: The bard Barry Patterson reciting his poem 'Dear Ancestors' at the Wroth Silver breakfast, The Queen's Head, Bretford, 11 November 2021. (Author)

that he had that day collected £7 and 2 pence and would therefore be dropping into Starbucks on the way home. Finally, David Eadon, continuing a 118-year family record, spoke to us on the history of the Wroth Silver ceremony. He gave many fascinating pieces of information. One of these was that the tenant of the field, who lives in the cottage next to it, always receives a shilling each year for cleaning out the stone prior to the ceremony. This shilling was duly handed over to the tenant who was present at the breakfast.

Different ideas have been offered for the origin of the tax, but latest research suggests the tax may have been originally levied to pay officers to protect people in the Hundred while going about their daily lives here in the Forest of Arden, which would have had its fair share of robbers, bandits and 'manslayers' (as they were known in Middle English). Non-payment of the dues incurs a fine; traditionally this was £1 for every penny not forthcoming (now 100p following decimalisation), or to produce a white bull with red ears and red nose. The bull forfeit may be an invention of the 2nd Duke of Montagu – known for his love of hoaxes – who possibly introduced this to spice up the ceremony in 1729. It is not enforced today.

David Eadon reached the end of his speech with a plea for many younger people to ensure the survival of this unique British tradition, as he is coming to the end of his Wroth Silver days. His concluding words were: 'I hope we all meet again next year to keep England's oldest ceremony alive.'

## The 800-year-old Ball Game in Atherstone

Thousands of people descend on the North Warwickshire town of Atherstone each year on Shrove Tuesday for an event that dates to the time of King John (who reigned from 1199 to 1216). At that time, it was called the 'Match of Gold'. Warwickshire and Leicestershire contested a bag of gold with a game of medieval football (some accounts even say the ball was a bag of gold) in a field between the two counties on Shrove Tuesday. Once a staple to many English towns, Atherstone is only one of two towns that now host a Shrove Tuesday Ball Game.

The Ball Game has always held a fearsome reputation for violence and score settling, during the battle for possession of the oversized ball that is thrown out of a first-storey window in Long Street at three o'clock in the afternoon. Crowds begin to build in Long Street ahead of the game around lunchtime, with many local schools having half days to allow children to participate. Each year a special guest throws out the ball. In the build-up to the big throw out, hundreds of sweets are thrown down for children along with a golden penny, which is worth £10 to the winner.

With a team of more than twenty marshals working the street to keep order, the children then move out and a predominately adult male crowd gather in anticipation for the throw out and the battle for the first possession. From around 4.30 onwards, the battle commences to become the person in possession when the klaxon sounds at five o'clock. The Chief Ball Game Marshall says:

Long Street, Atherstone, venue
for the Atherstone Ball Game.
(Courtesy of Jamie Robinson)

The Ball Game is now a charity. The winner goes around the pubs and clubs
raising money for their chosen cause. In the weeks leading up to the day, the ball
goes on tour to schools, sporting clubs, all sorts of places. It's a tradition that
means a lot to many people in Atherstone … the community coming together,
women, children kicking the ball and sharing in the history of the event.

## The Hand of Glory and the Gallows Healing: Warwick Gaol House Door and Site of the Former Town Gallows

Often when we look at the practices and beliefs of our forebears we may react
with disbelief and horror; none more so, perhaps, than in the area of public
executions and what happened to the executed criminals afterwards.

In Warwick, at the corner of Barrack Street and Northgate Street, opposite
Northgate Methodist Church, we may find the site of the former Warwick Town
Gaol, where the original door to the former prison cell still survives. The town
gaol adjoins The Old Shire Hall and Judges' House. Here it was that the town
gallows were sited; many met their gruesome end here, in sight of the good people
of Warwick who had come for a day out with their children to enjoy the public
hanging. But worse than that was their beliefs and actions in regard to the mortal
remains of the hanged criminal.

The Hand of Glory was the dried, pickled hand of an executed criminal, which,
when used as either a candle or a candle holder, was thought to have special

*Above left*: The site of the Warwick Town Gaol. Original door to the former prison cell. (Author)

*Above right*: Old Shire Hall and Judges House, Warwick. (Author)

magical properties. The fingers were sometimes used as a wick, or they might be bent around the candle, which was usually made from the fat of the dead criminal with his hair as the wick. This grim relic was popular among thieves who believed it would give light only to the holder while others were left in darkness. The term 'hand of glory' derives from the French 'main de glorie', the name for the supposedly magical mandrake root believed to grow under the gallows from the seed of a hanged man. The mandrake leaves were thought to resemble hands. In Saxon times, mandrakes were also believed to shine at night like a lamp, which may have added to the idea of a light for criminals.

This legend can be traced at least to the fifteenth century, but the name 'Hand of Glory' was only used later. Such items were highly prized by criminals in the sixteenth to early eighteenth centuries. There are cases of witches being accused of creating a hand of glory during the witch hunts of the sixteenth and seventeenth centuries. However, when the witch hunts ended with the dawn of the age of reason, the practice of creating Hands of Glory died out, along with belief in the protection they offered.

# The Gallows Healing

From the eighteenth century through to the abolition of public executions in England in 1868, the touch of a freshly hanged man's hand was sought after to cure a variety of swellings, such as 'wens'. While the healing properties of corpse hands in general were acknowledged and experimented with in early modern medicine, the gallows cure achieved prominence during the second half of the eighteenth century and is known to have been practised in Warwickshire. While frequently denounced as a disgusting 'superstition' in the press, this popular medical practice was inadvertently legitimised and institutionalised by the authorities through changes in execution procedure.

The last permitted 'public stroking' seems to have taken place at Warwick in April 1845, when several women were allowed to ascend the scaffold to have their wens rubbed, a local journalist describing the scene in these terms: 'as extraordinary as it was revolting to behold'. By the 1850s the authorities had put an end to the practice altogether, with prison governors rather than sheriffs taking the lead by tightening up access to the scaffold and removing the executioners' discretion to allow access. The governor oversaw security at hangings and ensured the execution was conducted humanely and efficiently.

In April 1863 an old woman from Tachbrook, Leamington Spa, and her daughter, who suffered a large unsightly wen on her throat, travelled the few miles to Warwick Prison for the hanging of the murderer Henry Carter. They called at the Porter's Lodge to request the governor to allow the hanged man's hand to be passed over her throat. Permission was not granted. This seems to have been the last reported application for the cure. Public hanging was abolished in the United Kingdom five years later, putting an end once and for all to a healing tradition that was both extraordinary and mundane, that became institutionalised and yet reviled.

Another view of Warwick Gaol House door. (Author)

# And Then the Whining Schoolboy: Lewis Carroll at Rugby School

> Then the whining school-boy, with his satchel
> And shining morning face, creeping like snail
> Unwillingly to school.
>
> *As You Like It* (Act 2, Scene 7)

Rugby School is renowned as the educational establishment where several famous authors were educated – whether they liked it or not. Lewis Carroll, author of *Alice's Adventures in Wonderland*, is in the latter category. As a schoolboy, the great writer, known by his real name of Charles Lutwidge Dodgson, studied there between 1845 and 1849, but he is known to have written some years after leaving the place:

> I cannot say ... that any earthly considerations would induce me to go through my three years again ... I can honestly say that if I could have been ... secure from annoyance at night, the hardships of the daily life would have been comparative trifles to bear.

We can only guess at the nature of the annoyances at night which he suffered. However, according to his schoolmasters, his academic record shone. 'I have not had a more promising boy his age since I came to Rugby,' observed R. B. Mayor, the maths master.

Later, he went on to Oxford to become a mathematics don, to meet Alice Liddell in the garden of Christchurch College and to create one of the world's most dearly loved stories, which begins with a picnic on an Oxford riverbank and continues with a fall down a rabbit hole. The fact that he held negative memories of his days at Rugby School does not stop Rugby from celebrating him. Accordingly, he is included in the list of illustrious authors who are commemorated in unusual and delightful sculptures called *The Writer's Rest*. You will find one of the sculptures in Rugby's Jubilee Gardens. Another is located in the gardens of the beautiful building known as the Percival Guildhouse.

The Guild promotes adult education and the arts in Rugby and uses the house for this purpose, in its ideal location alongside the Art Gallery, Museum and Library. The Guildhouse used to be the home of Matthew Bloxam, an archaeologist famed for discovering the Roman town of Tripontium close to Rugby, which lay undiscovered for 1,400 years and had once been a major town on Watling Street.

*The Writer's Rest* by sculptor Michael Scheuermann, in the grounds of the Percival Guildhouse, Rugby. (Author)

The Percival Guildhouse, Rugby, former home of Matthew Bloxam. (Author)

*Above*: Rugby Art Gallery, Museum and Library. (Author)

*Left*: Plaque on the Percival Guildhouse commemorating Matthew Bloxam. (Courtesy of Jamie Robinson)

The authors honoured by *The Writer's Rest* sculptures are all associated with Rugby because they were born or lived there and /or went to Rugby School. The sculptures create places of contemplation within a tranquil outdoor setting and started life as 3.6-ton blocks of 'Watts Cliff' sandstone, before being formed into luxurious outdoor seats with exquisite detailing – buttons, fabric folds, a book casually cast aside by its reader – all being hand carved over several months by artist Michael Scheuermann and his team of sculptors. The sculptures were commissioned by Rugby Borough Council Arts Development, who consulted and received feedback from local writers as well as community groups and individuals, and of course Rugby School. As a result of that process the writers chosen to be included beside Lewis Carroll were Rupert Brooke, Matthew Arnold, Gillian Cross,

Map of Roman Britain AD 369 to show the location of Watling Street crossing the Fosse Way. (Map by permission of FCIT)

Philip Toynbee, Arthur Ransome, Richard Grant, Thomas Hughes, John Gillespie Magee, Anthony Horowitz, Isabel Wolff, Andrew Norman Wilson, Percy Wyndham Lewis, Denys Watkins Pitchford, Salman Rushdie and Arthur Hugh Clough.

Perhaps this intriguing biographical detail about Lewis Carroll serves to confirm that even if we don't believe we are enjoying ourselves, our experience throughout our lives is of infinite value to those who use it creatively. This is the legacy of many of those individuals mentioned here, who together form part of the rich fabric of Shakespeare's County of Warwickshire.

# Bibliography

'Chris', 'The Crackley Wood Sprite', *Fortean Times* FT397, Oct 2020, p. 74

Atkins, Meg Elizabeth, *Haunted Warwickshire* (London: Robert Hale, 1981)

Beresford, Maurice, *The Lost Villages of England* (Stroud: Sutton Publishing, 1998)

Dugdale, Sir William, *Antiquities of Warwickshire* (UK: William Caxton, 1695)

Forest-Hill, Lynn, *Elves on the Avon: The Place of Medieval Warwick in J. R. R. Tolkien's Vision of Middle-earth* (UK: Times Literary Supplement)

Forest-Hill, Lynn, *Kortirion Among Trees: The Influence of Warwick on J. R. R. Tolkien's Vision of Middle-earth* (UK: The Tolkien Society)

Forrest, J, *The History of Morris Dancing 1458–1750* (UK: Cambridge, 1999)

Garth, John, *The Worlds of J. R. R. Tolkien* (UK: Frances Lincoln, an imprint of the Quarto Group, 2020)

Garth, John, *The Worlds of J. R. R. Tolkien: The Places That Inspired Middle-Earth* (UK: Frances Lincoln, 2020)

Harpur, Merrily, 'Anomalous Big Cats: The Mystery Continues', *Fortean Times* FT406, June 2021, pp. 32–37

Harpur, Merrily, *Mystery Cats* (UK: The Squeeze Press)

Harries, J., *The Ghost Hunter's Road Book* (London: Muller, 1968)

Hobbins, Cyril, *Traditional Wooden Toys: Their History and How to Make Them* (UK: Stobart Davies Ltd, 2007)

Johnson Ratcliff, S. H. and H. C., Warwick County Records vol III Quarter Sessions

Law, Dr Susan C., *Sarah Siddons: Bluestocking Actress* (unpublished MA by Research thesis, 2006)

Leslie, Anita, *Edwardians in Love* (UK: Hutchinson of London, 1972)

Lorimer, H., *Celtic Geographies: Old Culture, New Times*, ed. D. Harvey et al (New York: Routledge, 2001) pp. 91–109

Malyon, Mike, *Seems Like a Nice Boy: The Story of Larry Grayson's Rise to Stardom* (UK: Apex Publishing, July 2016)

Matthews, Rupert, *Haunted Places of Warwickshire* (Newbury: Countryside Books, 2005)

Midland Circuit Assizes, Crown Minute Book. John Davis's entry. *National Archives catalogue reference: ASSI 11/29. Reproduced under the Open Government License*

Morley, George, *Shakespeare's Greenwood: The Customs and the County* (London: David Nutt, 1900)

Nicholson, Tony, *The Definitive Biography of Larry Grayson* (UK: Kaleidoscope Publishing, Nov 2017)

Order Book Easter 1650 to Epiphany 1657 (Stephens, First Edition 1 Jan 1937), pp. 272–273

Patterson, Barry, 'Dear Ancestors' (unpublished poem written for Wroth Silver, 2021)

Smith, Mark, *The Dun Cow* (Warwickshire County Archives: Folklore and Myth)

*The Social History of Medicine* 28:4, Nov 2015, pp. 685–705( under the terms of a Creative Commons Attribution 4.0 International license)

Thorburn, Gordon, *The Classic Herb Garden* (UK: Grub Street 2010)

Tolkien, J. R. R. *The Lord of the Rings* (first published UK: George Allen & Unwin 29 July 1954) (more recent edition HarperCollins, 2013)

Tolkien, J. R. R., *The Hobbit* (first published UK: George Allen & Unwin, 21 Sep 1937) (more recent edition UK: Harper Collins, 2013)

Waddilove & Eadon, William & David, *Wroth Silver Today* (UK: W. Waddilove and D. Eadon, First Edition, Jan 1983)

Waddilove, William, and Eadon, David, *Wroth Silver Today: An Ancient Warwickshire Custom* (UK: William Waddilove and David Eadon, 1994)

Weiss, Dr Judith, translator, *Boeve de Haumstone and Gui de Warewic: Two Anglo-Norman Romances* (Arizona: State University of New York at Binghamton, Medieval & Renaissance Texts & Studies, 2008)

Wharton, C. S., *Folklore of South Warwickshire* (unpublished PhD thesis, 1974)

## Broadcast Material

BBC Television, feature length documentary *Larry Grayson: Shut That Door* (UK: BBC, broadcast 2021)

Ian Hislop, presenter, *Heroes for All Time*, part of a documentary series *Ian Hislop's Olden Days* (UK: BBC, first broadcast 9 April 2014)

## Websites

www.bbc.co.uk/coventry/features/weird-warwickshire/1945-witchcraft-murder

www.bbc.com/earth, for article by Robin Wylie, published online 9 Dec 2016

www.birminghamhistory.co.uk

www.british-history.ac.uk, for article by Charles Fairey, historian, on 'protective devices and witch marks'

www.business-live.co.uk, for article 'Warwickshire toymaker becomes Pinocchio's Geppetto for Disney', published online 31 May 2013

www.churchandstate.org.uk 'The Cunning Woman'

www.coventrytelegraph.net *Coventry Live* article by journalist Georgia Arlott posted online 17 January 2014.

www.hanleyswan.net, Michael Scheuermann, Sculptor for the Hanleys' Community Art Project

www.historyextra.com 'The Anglo-Saxon cunning woman'

www.muchadowarwickshire.wordpress.com, for article on 'land that time forgot slowly yields secrets'

www.mysteriesofmercia.com, story of Charles Walton

www.mysticmasque.com, for article by Charles Fairey, historian, on 'Grotesques and Gargoyles', published online 2014

www.nationaltrust.org.uk, for articles on Charlecote Park and 'Shakespeare and the poaching legend', and 'Where Was Shakespeare's Forest of Arden?'

www.paranormaleyeuk.co.uk

www.plumjerkum.co.uk/history

www.stocktonnews.org.uk

www.theculturetrip.com

www.thefreelibrary.com, for article by *Coventry Evening Telegraph* 'Meet Cyril, the real life Geppetto', published online 2008

www.victorianweb.org, biography of Lewis Carroll

www.warwickshire.gov.uk, Heritage and Culture, for information on St John's House Museum

www.windowonwarwickshire.org.uk

www.wrothsilver.org.uk article by Anne Langley, writing for the Warwickshire County Records Office, and comments in response to her article.

# Acknowledgements

Every attempt has been made to seek permission for copyright material used in this book. However, if we have inadvertently used copyright material without permission or acknowledgements, we apologise and we will make the necessary correction at the first opportunity.

The author and publisher would like to thank the following people and organisations for their support, co-operation and assistance, and for the use of stories and photographs:

*Coventry & Warwickshire Telegraph*, for 'Coventry and Warwickshire Myths and Legends: The Truth Behind Coventry and Warwickshire's Urban Legends and Myths', 7 March 2019

Warwickshire County Record Office, for story by Ratcliff and Flower (eds 1937) reference PH(N)212/56/3

George Evans-Hulme, for 'Forgotten local histories: The story behind the legend of Guy of Warwick', published online by the *Leamington Spa Courier*, Monday 30 August 2021

Peter Gray, Warwickshire County Record Office ref. PH(N)888/757

Philip Wilson, Trustee, Secretary and Archivist for the Warwickshire Yeomanry Museum Charitable Trust

Richard White, National Trust Gardener

Graham Lockley

Paula McBride, MA by Research in History

Emily Ward-Willis, three times great-granddaughter to Jane Ward, and her account published in the National Archives blog and reproduced under the terms of the Open Government Licence.

A source who has experience of working with Warwickshire Police (name withheld on request)

Cyril Hobbins, Traditional Wooden Toymaker ('The Toy Maker from Kenilworth')

Caroline Jones, Hedgerow Healer

Caroline Smedley, Historical Researcher

Adrian King, Custodian, Guy's Cliffe Centre, Warwick

Nuneaton Museum and Art Gallery

Mike Malyon, nephew of Larry Grayson

The Warwickshire Wildlife Trust, a leading Warwickshire independent conservation organisation, whose mission is to bring people closer to nature and create a land rich in wildlife. Those wishing to support their work may donate or become a member.

Dave and Pippa Hutchins of Plum Jerkum, Warwick's own Border Morris Side

Friends of Foundry Wood, registered charity no. 1157820: Achieving Results in Communities, No. 122 Brunswick Street, Leamington Spa, who lease land from Network Rail and protect it from future developments, improve habitat and biodiversity, and open it up to the public for local wildlife and heritage interest.

William Waddilove and David Eadon, organisers of the Wroth Silver ceremony, held annually on 11 November at the Knightlow Cross, Ryton-on-Dunsmore.

Barry Patterson for permission to quote from his poem 'Dear Ancestors'. Find Barry at www.redsandstonehill.net and www.songandstory.co.uk